Katsura Funakoshi

Skulpturen und Zeichnungen
Sculpture and Drawings

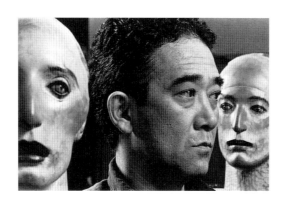

KATSURA FUNAKOSHI

Skulpturen und Zeichnungen
Sculpture and Drawings

Mit Textbeiträgen von • With essays by
Anna Bechinie
Dieter Brunner
Ferdinand Ullrich

KERBER VERLAG

Impressum • Imprint

KATSURA FUNAKOSHI

Skulpturen und Zeichnungen
Sculpture and Drawings

Die Publikation erschien
anläßlich der gleichnamigen Ausstellung
mit den Stationen
Annely Juda Fine Art, London
Kunsthalle Recklinghausen
Städtische Museen Heilbronn,
1999 – 2000

Fotografien • Photographs
Koichi Hayakawa
David Hubbard
Koei Iigima
Kenji Nishimura
Takahito Ochiai
John Riddy
Yoshitaka Uchida
Norihiro Ueno
(Photo Courtesy
Tochigi Prefectural Museum of Fine Art)

Herausgeber • Published by
Kunsthalle Recklinghausen
Städtische Museen Heilbronn
Annely Juda Fine Art, London

Konzeption und Layout • Design and Layout
Ferdinand Ullrich

Redaktion • Editing
Hans-Jürgen Schwalm

Korrektur • Proof-reading
Beatrice Behlen
Ingrid Disselkamp-Rieskamp

Übersetzung • Translation
Beatrice Behlen, London

Satz • Typesetting
Kunsthalle Recklinghausen

Schrift • Type
Stone Serif

Papier • Paper
Phoenix Imperial halbmatt, naturweiß 170g/m², Scheufelen

Gesamtherstellung • Production
Kerber Verlag Bielefeld

2. Auflage
© Kerber Verlag Bielefeld, 2000
die Autoren und Herausgeber

ISBN 3–929040–40–X

Vorwort

Eine Ausstellung Katsura Funakoshis in Europa stellt ein besonderes Ereignis dar. In den elf Jahren, die seit der ersten Präsentation seiner Skulpturen auf der 33. Biennale di Venezia 1988 vergingen, stellte er lediglich 1991 und 1996 in der Galerie Annely Juda Fine Art in London aus.

Manche Kritiker rückten Funakoshi kühn in die Nähe des Genies. Denn er besitzt das außergewöhliche Talent, sich als ein durch und durch zeitgenössischer Künstler zu behaupten und gleichzeitig eine stilistische Annäherung an die deutsche Renaissance sowie die Kunst der japanischen Kamakura-Zeit zu wagen. In ihrem informativen Katalogbeitrag stellt Anna Bechinie diese polare Spannung ausführlich dar.

Die aktuelle Ausstellung markiert einen wichtigen Schritt für die europäische Rezeption des bildhauerischen wie auch des zeichnerischen Werks von Katsura Funakoshi. Wir freuen uns sehr und sind dankbar, daß die Kunsthalle Recklinghausen, die Städtischen Museen Heilbronn und die Galerie Annely Juda Fine Art, London gemeinsam die erste museale Einzelausstellung des Künstlers in Europa realisieren konnten. Für das deutsche Publikum bot sich bislang lediglich zweimal die Gelegenheit, Skulpturen Funakoshis zu sehen: auf der Documenta IX 1992 in Kassel und zwei Jahre zuvor im Rahmen der Ausstellung „Japanische Kunst der 80er Jahre", die der Frankfurter Kunstverein präsentierte.

Unser Dank gilt zunächst allen Leihgebern, die bereit waren, sich auch für einen längeren Zeitraum von ihren Werken zu trennen, namentlich Frau und Herr Broska, Mainz-Kastell, Prof. Dr. Marcus Luther, Bonn, Alexander Walker, London, die Sammlung Ahlers, Herford, Museum Ludwig, Köln sowie zahlreiche Leihgeber, die ungenannt bleiben möchten. Da wir wissen, wie schwer es bisweilen fällt, sich auch nur für wenige Wochen von einem liebgewonnenen Kunstwerk zu trennen, bedanken wir uns sehr herzlich für ihre Großzügigkeit und ihr Vertrauen. Ohne ihre Hilfe wäre diese Ausstellung nicht möglich geworden.

Darüber hinaus unterstützten uns folgende Freunde und Kollegen bei den Vorbereitungen: Claude Bernard, Paris, Laurent Delaye, London, Annemarie Sander, Darmstadt, Paul Schönewald, Krefeld und Bernd Schultz, Berlin. Auch ihnen sei nachdrücklich für ihre Hilfe gedankt. Denn eine Ausstellung ist immer das Resultat gemeinschaftlichen Arbeitens und realisiert sich durch das Engagement vieler. Zu erwähnen ist auch das Engagement der Japan Foundation, Köln.

Besonderen Dank schulden wir auch Herrn und Frau Nishimura, Galerie Nishimura, Tokyo, die uns stets unermüdlich zur Seite standen. Last not least müssen wir uns aber bei Katsura Funakoshi bedanken, da allein sein Werk uns diese wunderbare Ausstellung ermöglichte.

Dr. Ferdinand Ullrich, Kunsthalle Recklinghausen
Dr. Andreas Pfeiffer, Städtische Museen Heilbronn
Annely Juda, Annely Juda Fine Art, London

Preface

Exhibitions of Katsura Funakoshi in Europe are rare events. In the eleven years since his sculpture was first seen at the Venice Biennale in 1988, he has shown at Annely Juda Fine Art in London on just two occasions in 1991 and 1996.

Funakoshi has sometimes been referred to as nothing less than a genius. He has the extraordinary talent to be a contemporary artist and yet simultaneously to be able to draw from the roots on the one hand of German Renaissance art and on the other hand ancient Japanese art of the Kamakura period. Anna Bechinie examines this and other issues in her illuminating essay.

The present exhibition marks an important moment in the European appreciation of Funakoshi's sculpture. It is with great pleasure that the Kunsthalle Recklinghausen, the Städtische Museen Heilbronn and Annely Juda Fine Art, London have been able to join forces to make the first solo museum exhibition in Europe of his work. For the German public there have only been two previous occasions when his sculpture was seen: at the Documenta IX, Kassel in 1992 and as part of the exhibition 'Japanese Art of the Eighties' at the Frankfurter Kunstverein in 1990.

We would like to acknowledge the support and help given to us by a large number of people in realising this exhibition. Firstly we should like to record our gratitude to all the lenders including Mr and Mrs Dieter Broska, Mainz-Kastell, Prof Dr Marcus Luther, Bonn, Alexander Walker, London, Collection Ahlers, Herford and Museum Ludwig, Köln and the many lenders who wish to remain anonymous. It is always a considerable sacrifice to be without a work of art one loves and agree to lend it for a period of time. We are therefore especially grateful to the lenders for we know how difficult this has been and their generosity is warmly appreciated.

We have received much support from the following friends and colleagues Claude Bernard, Paris; Laurent Delaye, London; Annemarie Sander, Darmstadt; Paul Schönewald, Krefeld and Bernd Schultz, Berlin and we wish to acknowledge their help with our gratitude. We would also like to acknowledge the assistance of the Japan Foundation, Cologne.

Our special thanks and gratitude to Mr and Mrs Nishimura from the Nishimura Gallery in Tokyo for all their tireless help and support. Finally and most importantly we should like to express our warm and sincere thanks to the artist for giving us such a wonderful exhibition.

Dr Ferdinand Ullrich, Kunsthalle Recklinghausen
Dr Andreas Pfeiffer, Städtische Museen Heilbronn
Annely Juda, Annely Juda Fine Art, London

Anna Bechinie

Katsura Funakoshi, Skulptur zwischen zwei Kulturen

Katsura Funakoshis Holzskulpturen sind von eindringlicher Intensität und zugleich zerbrechlicher Mystik. Was sind sie, diese Wesen, die teils aussehen, als seien sie alte Bekannte und teils ganz fremdartig wirken; die uns gegenüberstehen und doch einer anderen Welt anzugehören scheinen? Funakoshis Werk ist Skulptur zwischen zwei Kulturen, Okzident und Ostasien.

Ein Zusammenfluß unterschiedlicher kultureller Einflüsse ist in der heutigen Zeit der Vernetzung und Kommunikation sicherlich nichts außergewöhnliches. Und doch bringt gerade Funakoshi besondere Voraussetzungen für ein Werk zwischen den Kulturen mit: Er ist Japaner katholischen Glaubens; zum einen eingebunden in die Weltanschauung seiner Heimat, zum anderen durch seine Religion eher westlich orientiert.

Sein Vater, Yasutake Funakoshi, ein bekannter Bildhauer in Japan, hat ihn mit westlicher Formgebung und Ikonographie vertraut gemacht. Er schuf Werke aus Bronze und Stein sowohl christlicher als auch profaner Thematik, die eng seinem Vorbild Auguste Rodin verbunden sind. Funakoshis praktisch-künstlerische Ausbildung an der Universität bringt ihm durch akademisch-figürliche Arbeiten vor allem die Techniken westlicher Bildkunst nahe. Nur im theoretischen Unterricht steht die eigene Kunstgeschichte der Europas und Amerikas gleichwertig gegenüber. Neben diesem eher okzidentalen Einfluß steht aber der Lebensraum Funakoshis, der ihm tagtäglich in Menschen, Kultur und Kunst begegnet. Er manifestiert in seinen Skulpturen eine nationalitätenübergreifende Ausstrahlung von würdevoller und zugleich verstörender Ruhe. Seiner Formgebung liegen die Grundkonventionen der Menschendarstellung zu Grunde, die sich in Skulpturen vieler Jahrtausende manifestiert haben, von den Ägyptern, über die eigene Tradition und mittelalterliche europäische Figuren bis hin in unsere Gegenwart.

In vielen Beiträgen über Funakoshis Werk findet sich die Bemerkung, der Autor erinnere sich nicht mehr genau, wann er die Arbeiten des Künstlers zum ersten Mal sah. Der Eindruck entstehe, man begegne einem alten Bekannten. Als „archaisch" wird dies oft bezeichnet, als etwas Urbildliches, das essentielle Elemente des Menschlichen übermittelt und den Figuren ihre Zeitlosigkeit gibt.

Alle Arbeiten Funakoshis sind figürlich und doch gibt es eine große Bandbreite. Es gibt Skulpturen, die in ihrer Kleidung ganz unserem alltäglichen Leben entstiegen zu sein scheinen. Vor allem in Werken der letzten Jahre jedoch findet sich eine neue Abstraktion in den Torsi, die sie deutlicher unserer unmittelbaren Realität entrücken. Unabhängig vom künstlerischen Werdegang ist allen Figuren eine sehr intensive Präsenz zu eigen. Ihre klar geschnittenen Gesichter werden von geheimnisvoll glänzenden Augen beherrscht, die zugleich eine Verbindung zur Welt des Betrachters herstellen, aber auch an einer anderen Welt teilzuhaben scheinen. Die Realitätsnähe der meisten Figuren wird durch das Ausschnitthafte der Büstenform und die Sichtbarkeit des Materials teilweise wieder aufgehoben, die Skulpturen sind dadurch deutlich als künstlich geschaffene Entitäten zu erkennen. In eine der momentanen Realität enthobenen Welt scheinen zudem die in undefinierbare Ferne gerichteten Augen zu führen. Auch die Titel, die eine eigene Stimmung heraufbeschwören, entführen den Betrachter in eine andere Welt.

Will man der eigentümlichen Ausstrahlung Funakoshis Skulpturen auf den Grund gehen, sind besonders die unterschiedlichen Einflüsse von Ost und West zu beachten. Sind die Arbeiten Funakoshis rein äußerlich fast supranational, so ist ihre Ausstrahlung von würdevoller Stille. Ihre passiv wartende Haltung findet man

auch im Buddhismus beim geduldigen Warten auf die Erleuchtung.

Ohne die so lebendig und zugleich geheimnisvoll wirkenden Augen wären die Skulpturen Funakoshis nicht das, was sie sind: Wesen, die zugleich im Raum des Betrachters stehen, aber auch mit ihren Augen in großer Ferne zu weilen scheinen. Mit der Technik des Augeneinsetzens knüpft Funakoshi an die japanische Bildhauertradition an. Wichtig für die Gesamtwirkung der Skulpturen ist zudem die sehr selten verwendete Form der gelängten Büste, die bis kurz unter den Bauchnabel reicht. Mit der Wahl dieser Darstellungsform enthebt Funakoshi seine Figuren der direkten Realität, da sie deutlich als Ausschnitt zu erkennen sind. Zugleich verbindet er in dieser Form aber auch Kopf und Intellekt mit dem Organischen und Kreatürlichen des Menschen, was in der klassischen Büste, die mit einem Ansatz der Schultern und des Brustkorbes endet, nicht zur Geltung kommt. Eine große Bedeutung haben bei Funakoshi auch die oft geheimnisvollen Titel der Werke, die den Betrachter anregen sollen, in eine Welt einzutauchen, die mit der Skulptur in Verbindung steht. Bedenkt man die relative Expressionslosigkeit der Figuren und die kargen und wenig informativen Titel, so kann man auch einen Bezug zur japanischen Dichtkunst herstellen. Sie komprimiert ein weites Feld von Vorstellungen in wenigen Worten, die nicht etwas Bestimmtes ausdrücken, sondern Anstoß für Assoziationen sind.

Funakoshi und der christliche Glaube

Seine christliche Konfession führte Funakoshi nicht zu einer rein sakralen Kunst. Sie brachte ihn aber zu seinem nun ausschließlich verwendeten Material, dem Kampferholz. Noch im Studium, bekam der junge Künstler von einem Kloster den Auftrag, eine Madonnenfigur zu entwerfen. Bedingung war, daß die Skulptur aus Holz sein müsse. Noch nie zuvor hatte der junge Künstler in diesem Material gearbeitet und so folgte er dem Rat eines Professors, das relativ einfach zu verarbeitende Kampferholz zu verwenden. Bis heute arbeitet Funakoshi mit diesem Holz, dessen Härte, Geruch und Farbe ganz seinen Vorstellungen entspricht.

Die Aufgabe, eine Madonna zu schnitzen, führte Funakoshi verstärkt in die Bildwelt der mittelalterlichen europäischen Kunst ein. Vor allem ein Bildhauer fiel ihm dabei ins Auge, Tilman Riemenschneider (etwa 1460–1531), dessen Skulpturen durch die ruhige Präzision ihrer Form und einer gleichzeitig weichen und warmen Ausstrahlung bestechen. Funakoshis Arbeiten haben etwas von der würdevollen Stille und Versenktheit der Figuren des deutschen Meisters, was sich rein äußerlich an seiner klaren Formgebung und der feinen Ausarbeitung der Gesichter festmachen läßt.

In den religiösen Anschauungen Ostasiens und Europas prallen zwei sehr unterschiedliche Welten aufeinander. Japan charakterisiert sich im religiösen Bereich durch Politheismus, Kontinuität zwischen dem Göttlichen und Menschlichen, einer optimistischen Sicht auf die menschliche Natur und einer zyklischen Zeitanschauung sowie gruppenorientierter Ethik, deren Ziel die soziale Integration ist. Dem steht die christliche Welt entgegen mit ihrem Monotheismus, einem Bruch zwischen Göttlichem und Menschlichem, die Sicht des Menschen als Sünder, eine geradlinige, eschatologische Ausrichtung und eine innere Ethik, die auf das Individuum gerichtet ist, das am Ende alleine vor Gott steht.

Japan – Gegensatz und Einheit

Mag Funakoshi auch durch sein Elternhaus und die Religion relativ westlich geprägt sein, lebt er doch in Japan, einem Land, in dem das Christentum nur etwa 1 bis 2 % der Bevölkerung ausmacht. Sein Werk weist neben der oftmaligen „Supranationalität" auch spezifisch japanische Elemente auf: tiefste Stille, Innerlichkeit und Passivität. Es entspringt der japanischen Geisteshaltung des Shinto und Buddhismus, wonach man nicht durch aktives Tun zur Erleuchtung gelangt, sondern durch stille Versenkung und Geduld. Dies schließt die freudigen und lauten Feste des Buddhismus nicht aus, im Vordergrund steht aber das ruhige und gefaßte Element. Zudem bezieht sich der Künstler vor allem mit dem Einsetzen der Augen auf die japanische Tradition der Kamakura-Periode (1185–1333).

Die Hauptprägung Japans geht von Shinto und Buddhismus aus, also Elementen, die der westlichen Vorstellungswelt größtenteils fremd sind. Andererseits ist Japan heute ein Land, daß vor allem in den technischen Entwicklungen an der Spitze steht. Einige Viertel Tokios scheinen mit ihren Neonschriftzügen und hektischen Menschenströmen fast amerikanischer als Amerika zu sein. Andererseits gibt es aber noch eine stille, eine „altmodische" Welt. So besteigt etwa kein Arbeiter eine Baumaschine, solange nicht eine Zeremonie zur Beruhigung der Erdgeister, die durch das Bauvorhaben gestört werden könnten, vorgenommen wird. Urältestes und Modernstes existieren hier in extremer Weise nebeneinander.

Einem Fremden fällt die starke äußere Zurückhaltung der Japaner auf. Ein Beispiel mag hier das Verhalten in einer Tokioter U-Bahn zu Hauptverkehrszeiten sein. Trotz der physischen Enge wird eine Isolation des Einzelnen aufgebaut. Dies geschieht durch einen ungeschriebenen Verhaltenskodex, nach dem direkte Blickkontakte vermieden werden. Statt dessen wird die in der Bahn angebrachte Werbung fixiert, werden die Augen geschlossen oder der Blick schweift ziellos in die Ferne. Eine ruhige Ausdruckslosigkeit liegt auf den Gesichtern. Betrachtet man das Werk Funakoshis, so kann man auch dort eine ähnliche, stoische Ruhe auf den Gesichtern finden und Blicke, die unbestimmt in die Ferne wandern. In Gruppenaufstellungen von Funakoshis Arbeiten läßt sich eine entsprechende Isolation des Einzelnen feststellen. Die Skulpturen sind meistens in einem relativ großen Abstand voneinander aufgestellt, so daß schon räumlich kein Gruppengefüge entsteht. Selbst wenn die Figuren enger beieinander stünden, wäre jede doch für sich alleine, da keine den Gegenüber, ob Betrachter oder Skulptur, direkt anblickt. Die Augen fokussieren nicht, selbst wenn sie direkt nach vorne gerichtet sind. Jede der Figuren Funakoshis blickt in eine eigene Welt und ist dadurch von einem Mantel der Isolation umgeben. Die starke Zurückhaltung im Ausdruck von Gefühlsbewegungen entspricht aber auch der alten Tradition der Selbstbeherrschung, die der Ritterethik der Samurai und dem Konfuzianismus entstammt.

Assimilation unterschiedlichster Einflüsse: Eine alte Tradition in Japan

Japan hat eine besondere Tradition der Assimilation verschiedenster Einflüsse entwickelt. Basierend auf seiner geographischen Lage als Insel, die nahe genug am Kontinent liegt, um von dort mit neuen Religionen und Kunstformen konfrontiert zu werden, aber weit genug entfernt, um einer Besetzung zu entgehen, ist Japan von den verschiedensten Einflüssen geprägt. Das Land schwankte zwischen Perioden großer Offenheit nach Außen und Zeiten völliger Isolation. Japaner haben über die Jahrhunderte hinweg viele äußere Einflüsse assimiliert und dann zu etwas „Japanischem" transformiert. Mit der Meiji-Periode ab Mitte des letzten Jahrhunderts wurde die Kunst der westlichen „Moderne" nach Japan gebracht. Mit ihr kamen bisher unbekannte Begriffe wie „Originalität" und „individuelle Schöpferkraft" ins Land. Zuvor und noch weit bis in das 20. Jahrhundert hinein war die japanische Kunst vor allem durch eine sehr starke Schüler-Meister-Bindung geprägt. Ziel war es, das Können des Meisters zu erlangen, nicht so sehr, etwas ganz Neues zu schaffen. Mit der Öffnung zum Westen gesellte sich nun zu dieser sehr gruppen- oder meistergebundenen Kunst eine individualistische Kunst hinzu. Auch Funakoshi steht zwischen Individualität und Ganzheit: Er schafft einzelne Personen, die aber für das Ganze der Menschheit Ausdruck sein sollen. Selbst wenn Funakoshis Skulpturen auf persönliche Freunde oder Erfahrungen zurückgreifen, so macht er dies nicht deutlich. Eine expressionistische künstlerische Haltung ist in Japan eher ungewöhnlich. Tritt sie auf, so vermeidet sie doch einen rein persönlichen oder autobiographischen Bezug. Expressive Werke weisen über das Individuum oder sogar die Kultur hinaus, sie drücken allgemein menschliche Probleme und Erfahrungen aus.[1]

Funakoshis Bild des Menschen

Die Motivation, sich rein figürlich und auf den Menschen bezogen auszudrücken, ist am besten durch Funakoshis eigene Worte zu vermitteln:

'Meet a far-sighted person.

He walks on narrow city streets but what he sees is the vast space between mountain peaks. Does he see a great bird spreading its wings, or a dark forest in the distance? Perhaps he's looking at that part of himself that lies farther away than anything else in this world. Indeed, it seems to me that one cannot see farther than inside oneself.

Maybe that's why I sense a certain kinship between the eyes of desert nomads and fishermen and the eyes of philosophers. People with such eyes are rare, but they can be found in all walks of life. Without warning, they pass before me. I cannot call to them - I can only struggle to see them and hear their softly spoken words. To me, their gestures and their eyes somehow embody the humanity in all of us.

Some people say that in knowing oneself one may know the world. The words to express this world are already present within each one of us, and our job is to search them out and read them one by one. All of this seems very important to me.

If I am able to see the world clearly by looking within myself, then I can make a statement concerning human existence through the depiction of a single person. Because I feel this way, I shall continue to work with the human form.' [2]

Nicht nur das intensive Interesse Funakoshis am Menschen findet hier seinen Ausdruck, sondern auch seine Wertschätzung des Auges. Die poetisch-träumerische Formulierung des Textes erinnert an die Titel seiner Werke, die einer ganz eigenen Poesie unterliegen. Die Worte Funakoshis sind keine Interpretation seiner Arbeiten, sondern ein Ausdruck seiner Motivation, seiner Gedankenwelt.

Eindeutig stellt Funakoshi den Menschen in den Mittelpunkt: Es ist sein Wunsch, menschliche Figuren zu formen, die ihre Umgebung und deren Atmosphäre wiedergeben. Das Augenmerk ist auf das Individuum gerichtet. Die Suche nach sich selbst, in gewisser Weise eine Sinnsuche, wird in den Menschen hineinverlegt. Gegen diesen Anthropozentrismus steht das japanische Weltgefüge, in dem der Mensch nur ein Element im Universum ist. Interessant ist, daß sich Funakoshi auch auf Novalis' „Heinrich von Ofterdingen" bezieht. Die Suche nach der „blauen Blume" führt ins Unterbewußtsein. Er besinnt sich auf die Worte des Mädchens am Spinnrad: „Ein jeder lebt in Allen und all' in Jedem auch" und „Wer kennt die Welt?" fragt die Sphinx das Mädchen, „Wer sich selbst kennt"[3] antwortet dieses.

Daneben steht das japanische Element: Der Einzelne mag zwar in sich selber suchen, steht damit aber gleichzeitig für das große Ganze. Natürlich finden sich auch in Japan Darstellungen des einzelnen Menschen, vor allem in der Geschichte der buddhistischen Bildhauerei. Hier jedoch ist der Mensch nicht auf der Suche nach sich selbst dargestellt, sondern als ein Meister, der eine höhere Lehre vermittelt.

Das Bildnis in der ostasiatischen Kunst

Die Werke Funakoshis sind Bildnisse von Menschen. Zwar kann in den meisten Fällen nicht von einem Porträt gesprochen werden, da eine Identifizierung im Titel meist ausbleibt und auch keine attributiven Erkennungsmerkmale bestehen. Die Bildnisse buddhistischer Priester sind als Porträt einer bestimmten Person benannt und doch geht es um mehr als die äußere Ähnlichkeit, es geht um ihre Ausstrahlung. Nicht nur die Erinnerung an das Äußere der dargestellten Person ist von Bedeutung, sondern die durch sie vermittelte Lehre. Schon früh (ab 400 nach Chr.) wurde als Hauptaufgabe des Porträts die „Übermittlung des Geistes" hervorgehoben und man „betonte auch später noch unermüdlich den Vorrang der geistigen und psychologischen Wahrheit vor der bloß optischen Erscheinung. Für die Bewertung eines Kunstwerkes war allein das Ch'i- yün schen t'ung des Hshieh Ho (5. Jh.) von Bedeutung: den Hauch und die Bewegung des Lebens selbst wiederzugeben". [4]

Während der Kamakura-Periode vollzog sich in der japanischen Holzskulptur ein entscheidender Schritt zur Realitätsnähe. Mit dem Aufkommen der „Pure-Land-Buddhisten" in dieser Zeit vollzog sich ein Wandel

von der Schriftgebundenheit hin zum gesprochenen Wort des einzelnen Priesters. Dieser und die von ihm vermittelte Lehre gewann an Bedeutung und so entstanden viele Mönchs- und Priester-Bildnisse. Die Arbeiten dieser Zeit bestechen durch eine Ausstrahlung des versenkten In-Sich-Ruhens. Sie vermitteln den Glauben, daß Erleuchtung nicht durch Aktivität zu erlangen ist, sondern nur dem wahrhaft Stillen und Geduldigen geschenkt wird. Eine Ähnlichkeit mit den dargestellten Personen ist eher unwichtig. Dieser Aspekt wird auch im Werk Funakoshis deutlich. Die Arbeiten wirken unabhängig von ihrer Porträthaftigkeit, die meistens verschleiert wird. Dargestellt ist erstrangig ein Mensch.

Funakoshi greift für seine Arbeiten teils auf Modelle zurück, teils entstehen die Gesichtszüge aber auch aus seiner Phantasie. Einige Arbeiten sind regelrecht „porträtiert", also sehr nah am Modell, manchmal kombiniert er zwei Fotos oder vermischt unterschiedliche Elemente zu einem neuen Gesicht. Als Porträt sind nur zwei Arbeiten Funakoshis ausdrücklich gekennzeichnet, „Portrait of my Wife" (1981) und „Portrait of Nakano" (1982).

Das Auge: Fenster zur Welt und ins Innerste des Menschen

Die Augen sind es, die Funakoshis Arbeiten ihre geheimnisvolle Lebendigkeit verleihen. Sie sind zugleich nach innen und außen gerichtet, irritieren den Betrachter dadurch und nehmen seine Aufmerksamkeit gefangen. In den meisten Fällen sind die Augen von Funakoshis Figuren auf nichts Äußeres gerichtet, wie bei einem in Gedanken versunkenen, nach innen blickenden Menschen.

Angeregt durch die Skulpturen der Kamakura-Periode setzt Funakoshi 1982 zum ersten Mal Marmoraugen in eine Skulptur ein. Traditionell wurden Kristallkugeln verwendet, die mit Papier oder Seide hinterlegt wurden, auf die Pupille und Iris aufgemalt waren. Kleine Fäden aus roter Baumwolle wurden zwischen Papier und Kristall gelegt, um so den Eindruck der feinen Äderchen im Auge hervorzurufen. Auch dies übernahm Funakoshi von den Skulpturen seines Landes. Er bedient sich auch der gleichen Technik des Einfügens und Fixierens der Augen, wie die japanischen Bildhauer des 12. bis 14. Jahrhunderts.

Augen sind „Fenster" zur Welt und gleichzeitig in das Innere des Menschen hinein. Daß dem Auge eine besondere Bedeutung zukommt, fällt auch bei der Betrachtung der Skulpturgeschichte auf. Die Bandbreite der Augengestaltung reicht von Augäpfeln, denen Iris und Pupille eingekerbt sind, um ihnen einen lebendigeren Blick zu verleihen, über bemalte Augen, bis hin zu eingesetzten Augen unterschiedlichster Machart. Innerhalb dieser weitgefächerten Gestaltung nimmt die japanische Technik eine besondere Stellung ein: Griechische Statuen hatten Emaille- oder Metall-Augen, ägyptische Bildhauer benutzten bemalte Steine und einige chinesische Beispiele zeigen die Verwendung eines schwarzen Steines, der als Pupille eingesetzt wurde. Aber nur die Japaner machten Augen aus transparentem Kristall, das mit bemalter Seide oder Papier hinterlegt wurde. Wie sehr das Auge mit dem Leben verbunden wird, zeigt eine Zeremonie der Augenöffnung im Japan des 8. Jahrhunderts. Bei der Einweihung des Todai-ji Tempels von Nara wurden der Buddha-Skulptur die Augen von einem indischen Mönch eingemalt, was die Skulptur ins Leben rufen sollte.[5]

Die Büste einmal nicht als reine Betonung des Intellekts

Die klassische Form der Büste reduziert die Darstellung des Menschen auf den Kopf in Verbindung mit einem Oberkörperausschnitt. In der Malerei, immer ausschnitthaft, wirkt die Reduzierung einer Person auf die Büste nicht als Reduktion. Bei der Skulptur hingegen ist die Büstenform die Verletzung einer körperlichen Ganzheit. Mit der Reduktion auf einen Ausschnitt wird der Abstand des Kunstwerkes zur Natur deutlicher. Die Beschränkung auf den Kopf und einen unterschiedlich tief geschnittenen Torso lenkt die Aufmerksamkeit des Betrachters auf den Menschen als geistiges Wesen. Das sinnliche Moment weicht damit dem intellektuellen.

Die Büstenform Funakoshis hebt sich davon ab, da sie bis knapp unter den Bauchnabel reicht. Der Künstler fand zu dieser sehr eigenen Büstenform, da ihm die „klassische" zu sehr auf den Charakter, den Intellekt

der Person beschränkt schien. Das Gesicht alleine gibt für ihn noch keine volle Präsenz. Hingegen leistet dies verstärkt eine über das übliche Maß hinaus vergrößerte Büste.

In der verlängerten Büstenform schafft Funakoshi eine figürliche Form zwischen Geistigkeit und Körperlichkeit. Funakoshis Arbeiten stehen auf dem schmalen Grat zwischen Realität und Irrealität, zwischen Leben und Kunst. Weder Material noch Arbeitsspuren werden vertuscht. Wäre die Gestaltung zu glatt, könnten die Skulpturen Schaufensterpuppen ähneln, was durch die alltägliche Kleidung noch betont würde. Es ist aber auch die Form der Büste, die die Figuren der direkten Realität enthebt. Eine ganzfigurige Skulptur ist wirklichkeitsnäher, sie steht sozusagen mit beiden Beinen in der Wirklichkeit.

Titel als Tor zu einer anderen Welt

Schlichte und eindeutig deskriptive Titel sind bei Funakoshi eine Seltenheit. Gewöhnlich muten seine Titel poetisch oder gar geheimnisvoll an. Charakteristisch ist, daß keiner dieser Titel erraten läßt, ob die dargestellte Person porträtiert oder frei gearbeitet ist. Ein Ziel Funakoshis ist es, den Betrachter in die Welt seiner geschaffenen Figur zu führen. Er möchte, daß der Betrachter mehr sieht als nur das Äußere. Die Titel entstehen nach Vollendung der Arbeit, wie die Namensgebung eines Kindes.

„Number of Words Arrived" und „Number of Words Unarrived" sind Titel von Porträtbüsten des britischen Bildhauers Anthony Caro, die Funakoshi wählte, da Caro ständig neue Ideen habe, die man in Werke umsetzen könnte. Von der Gesamtheit der Ideen werden aber nicht alle umgesetzt: „Number of Words Arrived" (in die Tat umgesetzte Ideen) und „Number of Words Unarrived" (nicht umgesetzte Ideen).

Zwar lassen sich unter den Titeln kaum zusammenhängende Gemeinsamkeiten finden, doch fallen einige Begriffe wie „Wasser", „Worte" und „Berg" durch häufigere Verwendung auf. Der Begriff „Wasser" taucht erstmals im Titel der Skulptur „Staying in the Water" von 1991 auf. Er entstand, da sich der Künstler an ein Erlebnis im Schwimmbad erinnerte: Ganz allein in einem Becken blieb er so lange unter Wasser, wie er den Atem anhalten konnte und schaute sich mit der Taucherbrille um. Er verbindet dieses Erlebnis mit dem der Selbsterkenntnis.

Ab 1994 taucht das Wort „Berg" häufiger in den Titeln auf. Die Verwendung dieses Begriffes geht auf ein persönliches Erlebnis des Künstlers zurück. Zu Studienzeiten sah er von der Universität aus einen Berg. Eines Tages kam ihm der Gedanke, daß der Berg kraft menschlicher Vorstellung in seiner ganzen Größe im Menschen selbst existiere. In der Folge entstanden Werke mit massiv wirkenden Torsi, die so an einen Berg erinnerten. Diese Entwicklung kann man auch als einen Schritt weg von rein figürlichen („realistischen") hin zu konzeptuelleren Arbeiten sehen.

Stille statt Expression

Besonders herausragend bei Funakoshis Figuren ist der Eindruck der Stille, der emotionslose Gesichtsausdruck und der Verzicht auf erzählerische Gestik sowie ein Gefühl der Zeitlosigkeit. Sie stehen in ihrer Körperlichkeit dem Betrachter gegenüber, befinden sich in diesem Sinne also in der unmittelbaren Gegenwart. Ihr ruhig gesammelter Blick aber scheint in eine andere Ebene, eine andere Zeit zu gehen. Funakoshi wählt ganz gezielt einen eher undefinierten Ausdruck für seine Figuren. Für ihn läßt sich in der Stille alles ausdrücken, – ob Weinen oder Lachen. Zum konzentrierten Gesichtsausdruck gesellt sich ergänzend eine Reduktion der Gestik in den meisten Arbeiten Funakoshis, wobei die fehlenden Hände diesen Eindruck noch stützen. Je neutraler die Gestik ist, desto weniger wird der Gesamteindruck eines Werkes vorgegeben, was den Assoziationen des Betrachters weiteren Spielraum gibt. Die Stille wird Quelle für geistige Bewegung.

Weniger sagt mehr

Ausgehend von den poetisch geheimnisvollen Titeln und erneut vom reduzierten und gleichzeitig so reichen Ausdruck der Figuren, stößt man auf die japanische Dichtung. Waka (31 Silben) und haiku (17 Silben)

nennen sich die kurzen, für den westlichen Betrachter oft unzusammenhängenden Gedichte, die von Assoziationen leben. Das waka versucht mit Hilfe von Wörtern, durch Allegorien, Metaphern und Gleichnissen ein Assoziationsnetz zu schaffen. Die Überschau des Ganzen und das daraus resultierende Assoziationsnetz könnte man als ein „Feld" verstehen, in dem die Zeit stillsteht oder aufgehoben ist, da die Bedeutung aller Wörter gleichzeitig in einer einzigen Sphäre gegenwärtig ist.[6]

Ein haiku des Dichters Bashô (1644–1694) zeigt, welche weitgefächerte Bedeutung wenige Worte haben können. Zudem paßt es von der Stimmung zu den Skulpturen Funakoshis und verdeutlicht die Verbindung seines Werkes zur japanischen Kultur:

furuike ya	The quiet pond
kawazu tobikomu	A frog leaps in
mizu no oto	The sound of water [7]

Dieses haiku wird gemeinhin als ein Beispiel der Manifestation von Ewigkeit und Ruhe angesehen. Zen-Anhängern gilt es symbolisch für die unmittelbare Weisheit. Ewigkeit, also unendlich ausgedehnter Raum oder endlose Zeit, kann man sich auch in der Stille vorstellen. Bewußt wird dieser Zustand der uneingeschränkten Ausdehnung aber erst durch die Unterbrechung des Klanges von Wasser, das durch den Sprung des Frosches bewegt wurde. Man kann dahinter auch das Prinzip der Gegensätze sehen: Stille ist nicht ohne das Wissen um Lärm ausmachbar, uneingeschränkte Zeit nicht ohne den Augenblick. Überträgt man diese Gedanken auf die Arbeiten Funakoshis, so kann man auch hier sagen, daß der Ausdruck von Zeitlosigkeit erst durch die momentane Präsenz des Betrachters zur Geltung kommt.

Das Kunstwerk als Aufruf zur Selbstbesinnung

Funakoshi integriert so unterschiedliche Welten, wie die Ostasiens, Europas und Amerikas in seiner Kunst zu einem Ganzen. Er zeigt Menschen, die in ihrer kulturellen Identität nicht unbedingt festgelegt sind. Die Zugehörigkeit eines Menschen zu einer Nation ist nebensächlich, was zählt, ist der Blick in die Tiefen seines Selbst, auf der Suche nach dem Stein der Erkenntnis am Grunde seines inneren Sees. Diese Suche manifestiert sich in der Ausstrahlung tiefster Ruhe und Zeitlosigkeit von Funakoshis Figuren. „Das Kunstwerk ist Aufruf zur Selbstbesinnung, indem es den Betrachter aus dem Bereich des praktischen Lebens heraushebt, ihn in eine andere Welt versetzt, ihn 'verzaubert'. Deuten bedeutet demnach Selbstgestaltung dem Kunstwerk gegenüber. Darin liegt das Ethos der Kunst begründet, seine geistige Beziehung und Wesensverwandtschaft zur Religion ..." [8]

1 Vgl. Koplos, Janet, *Japan. Contemporary Japanese Sculpture,* New York/London/Paris 1991 (= Abbeville Modern Art Movements), S. 16.

2 Funakoshi, in Kat. *XX Biennal de São Paulo 1989 Japão,* The Japan Foundation, 1989, S. 18.

3 Novalis, *Das dichterische Werk; Tagebücher und Briefe,* hrsg. v. Samuel, Richard, München/Wien 1978 (= Novalis. Werke, Tagebücher und Briefe Friedrich von Hardenbergs, hrsg. v. Hans-Joachim Mähl und Richard Samuel, Bd. I), S. 351 und S. 357.

4 Elisseeff, Danielle und Vadime, *Japan. Kunst und Kultur,* übers. v. Hedwig und Walter Burkart, Axel Küchle, Monika Marutschke und Brigitte Weiss, 2. Aufl., Freiburg/Basel/Wien, 1987, S. 173.

5 Vgl. Kyotaro, Nishikawa, *Japanese Buddhist Sculpture,* in Kat.: *The Great Age of Japanese Buddhist Sculpture. AD 600 – 1300,* Nishikawa Kyotaro, Emily J. Sano, Kimbell Art Museum, Fort Worth, 8.9. bis 31.10.82; Japan House Gallery, New York, 23.11.82 bis 16.1.83, Kyoto 1982, S. 24.

6 Vgl. Toshihiko, Izutzu, *Die Theorie des Schönen in Japan: Beiträge zur klassischen japanischen Ästhetik,* hrsg. von Franziska Ehmcke (aus d. Englischen u. d. japan. Orig. Texten übers. von Franziska Ehmcke), Köln 1988, S. 13.

7 Bowers, Faubion, *The Classic Tradition of Haiku, An Anthology,* Mineola, New York 1996 (zit. Bowers '96), S. 15.

8 Frey, Gerhard, *Zur Deutung des Kunstwerks* (1958), aus *Konkrete Vernunft, Festschrift für Erich Rothacker (zum 12. März 1958),* hrsg. von Gerhard Funke, Bonn 1958, S. 377–394, in Frey, Dagobert (Hrsg.): *Bausteine zu einer Philosophie der Kunst,* Darmstadt 1976, S. 83 – 112.

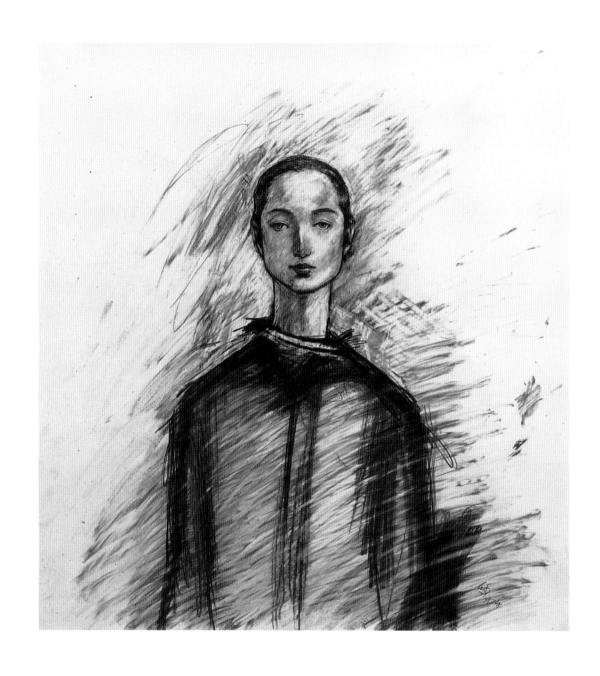

Drawing 9917, 1999
The Distance from Here, 1991

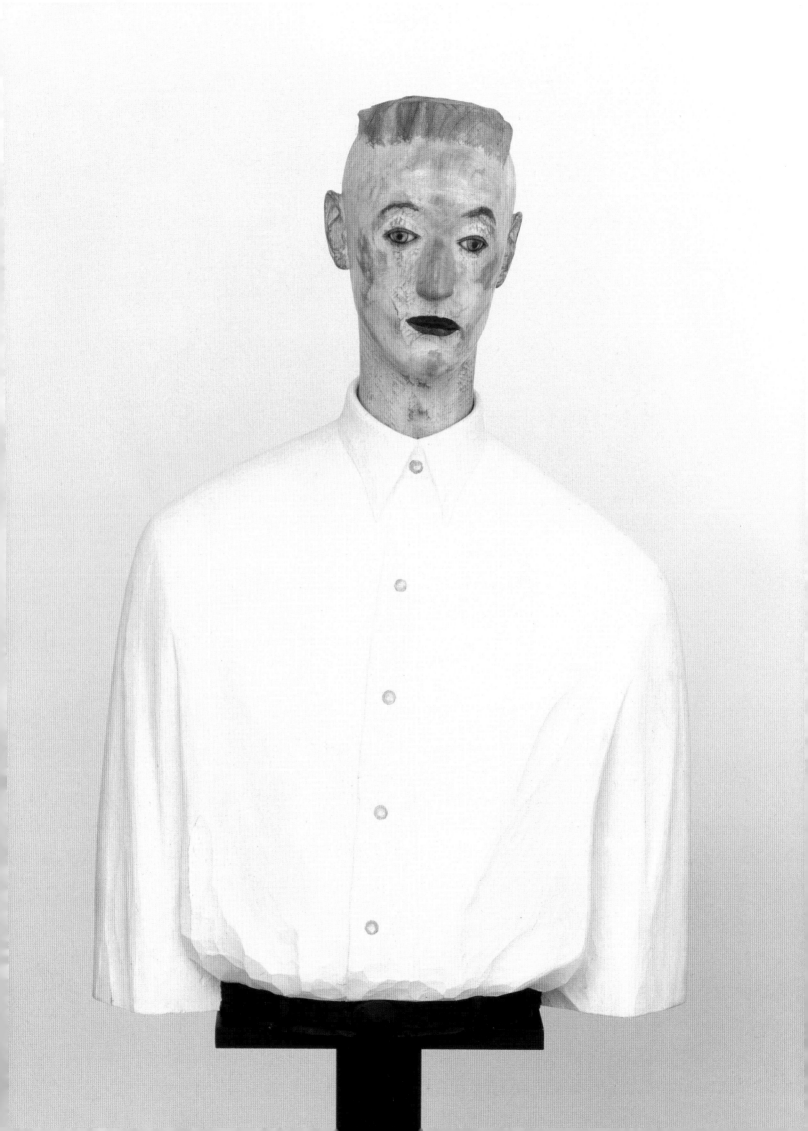

Drawing 9528, 1995
The Pendulum above the Water, 1991

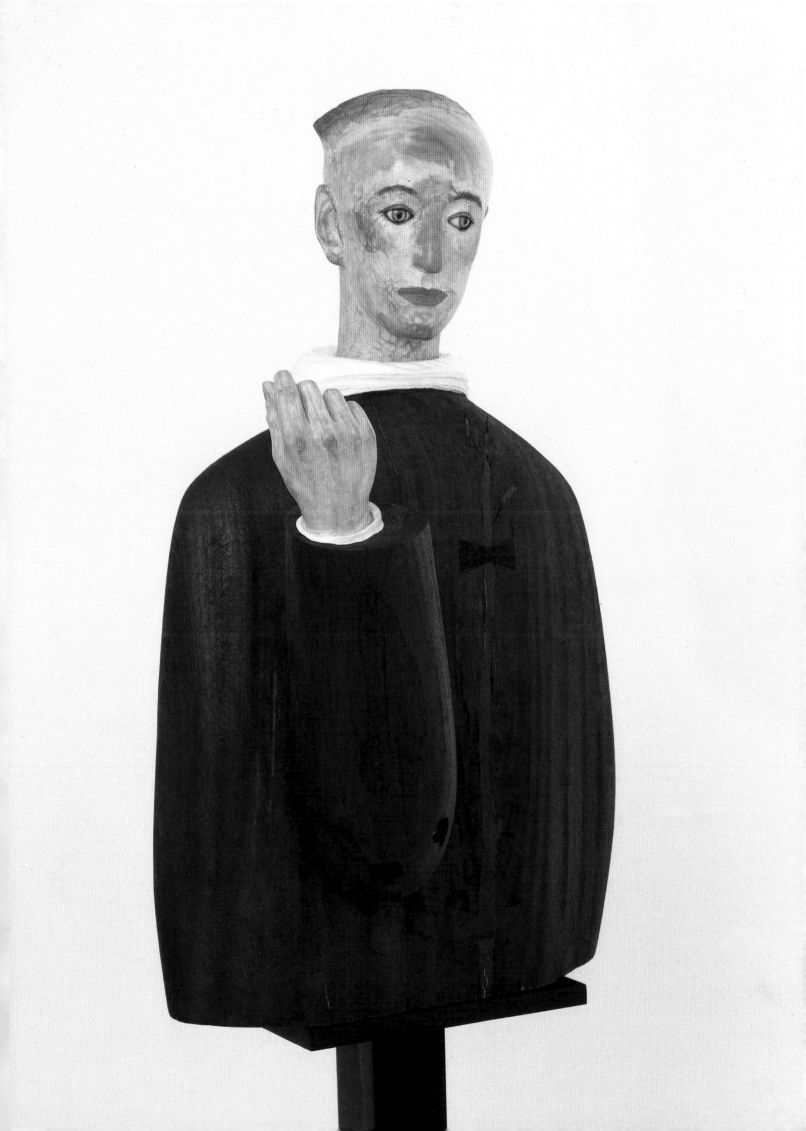

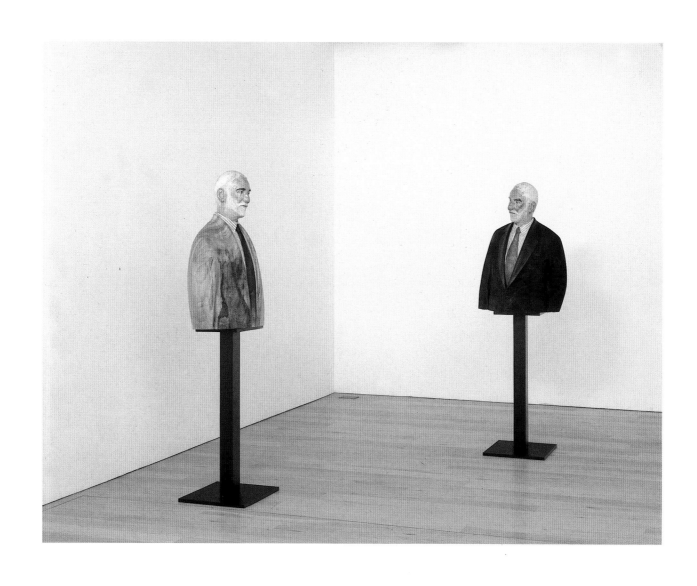

Number of Words Unarrived, 1991 • Number of Words Arrived, 1991
(Installation View at Annely Juda Fine Art, 1991)
Number of Words Arrived, 1991

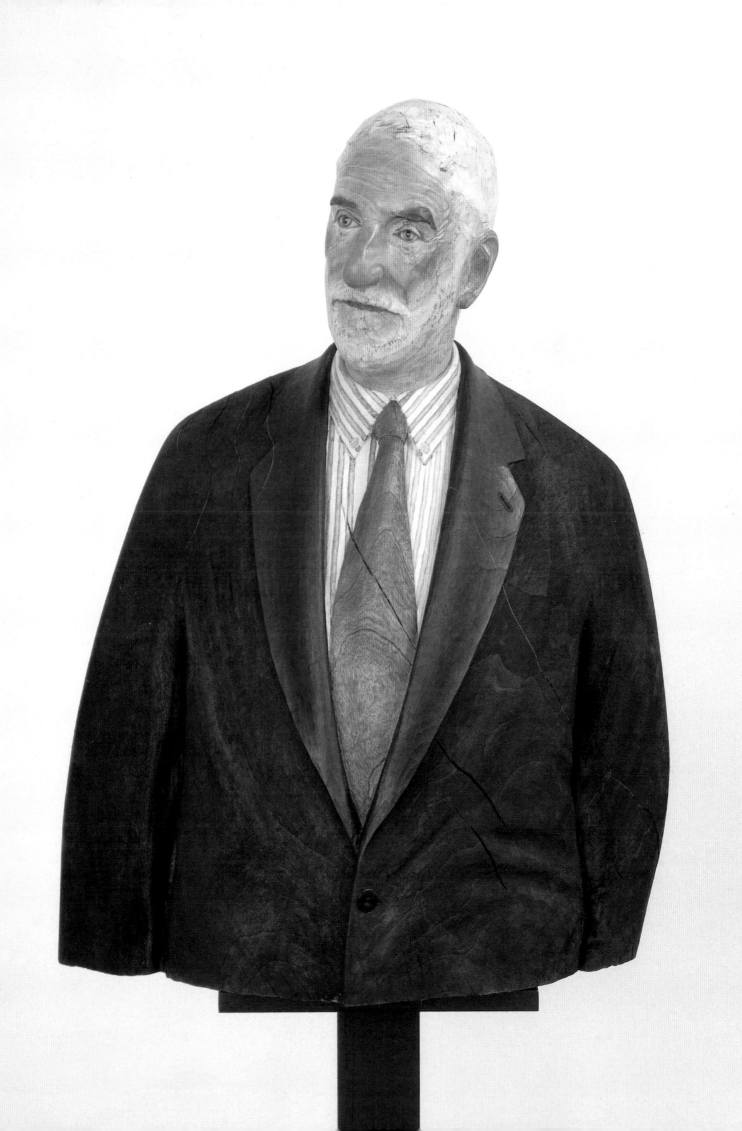

Anna Bechinie

Sculpture between two Cultures – Katsura Funakoshi

Katsura Funakoshi's wood sculptures are of striking intensity but at the same time possess a fragile mysticism. What are they these beings, which look as if they are old friends but also somehow alien, which stand beside us yet nevertheless seem to belong to a different world? Funakoshi's sculptures are between two cultures, the West and the East.

The merging of different cultural influences is of course nothing unusual in our time of networks and instant communications. However, Funakoshi is especially well equipped to work between cultures: He is both Japanese and Catholic and therefore simultaneously integrated both in the philosophy of life of his home country yet also orientated towards the West through his religion.

His father, Yasutake Funakoshi, a well-known sculptor in Japan, introduced him to Western art forms and their iconography. His father created works in bronze and stone using Christian as well as other subject matter and was very much influenced by Auguste Rodin. Katsura Funakoshi's practical artistic training was through a very academic-figurative syllabus at university which demonstrated the techniques of Western imagery. Only in the theoretical teaching was his own native history of art regarded as equal to that of Europe and America. Combined with this occidental influence is Funakoshi's home environment with its people, culture and art which he encounters everyday. Funakoshi's sculptures radiate an aura of dignified yet at the same time disturbing calm that transcend national identities. His forms are based on the fundamental rules associated with the depiction of human beings that have developed in sculpture over many millenniums from the Egyptians, through the indigenous Japanese tradition and European mediaeval figurative art, to the present.

In many texts on Funakoshi's works one notices that the author can never quite remember when he had first encountered the artist's work just as if they had met an old friend. This experience is often described as 'archaic' or something archetypal which relates to the basic elements of human existence and this imbues his figures with their timelessness.

Although all of Funakoshi's works are figurative they are very diverse. Some sculptures seem to have stepped out of our daily life, an impression that is given emphasis by their contemporary clothes. However, specially in more recent works, a new abstraction has emerged with his treatment of the torso which then clearly removes his figures from our immediate reality. But quite independently of his artistic development, all of Funakoshi's figures possess a very intense presence. The clear cut faces that are dominated by their mysterious shining eyes appear to establish a connection between the world of the viewer whilst at the same time seeming to be part of another world. The closeness to reality of most of his figures seems to be contradicted by the use of the bust-shape which represents only a part of the human figure (together with the fact that the material he uses is not concealed). The sculptures are thus clearly recognisable as artificially created entities. The eyes, turned towards an indefinite distance, also seem to lead to a world removed from immediate reality. The titles of the sculptures conjure up their own mood and carry the viewer into another world.

The different influences of East and West are of particular importance in establishing what lies behind the extraordinary aura of Funakoshi's sculptures. If on the surface Funakoshi's works transcend a national

The Box of the Moon, 1991

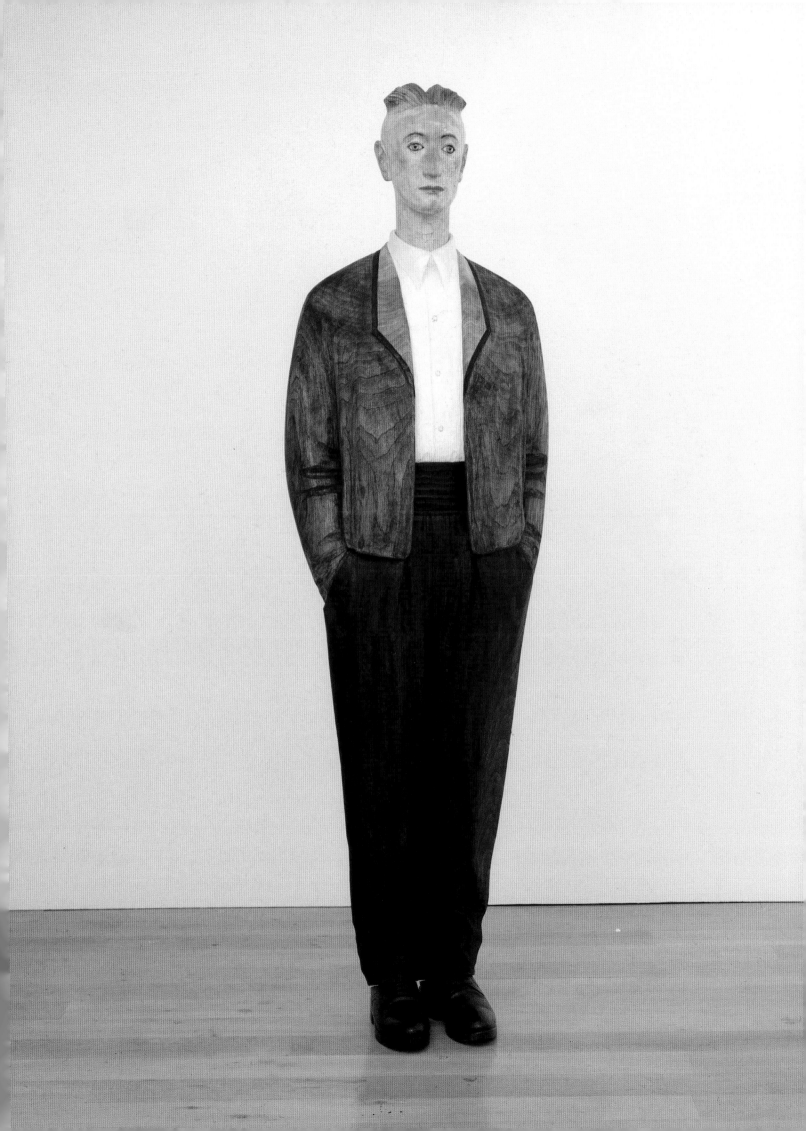

identity they at the same time possess a dignified calm. Their passive and attentive attitude is also reflected in Buddhism – the patient waiting for enlightenment.

However, it is their mysterious eyes which also seem alive that make Funakoshi's sculptures into what they are. The technique Funakoshi uses to insert eyes into his sculpture establishes a link with the tradition of Japanese sculpture of the Kamakura period. Also important for the overall impression of the sculptures is the rarely used form of the elongated bust reaching to just below the navel. He liberates his figures from immediate reality by choosing this form which is clearly only a partial representation of the whole. At the same time with this form both the head and intellect seem united with the organic and natural side of man. This is normally hidden in the shape of the standard classical bust that usually only reaches the line of the shoulders and part of the upper body. Of equal importance are the often mysterious titles of his sculptures which attempt to induce the viewer to enter their world. Given the relative lack of expression in Funakoshi's figures and his sparing and not very informative titles, his work also can be related to Japanese poetry which compresses a wide range of ideas into a few words that do not express anything definite but just evoke associations.

Funakoshi and Christian Faith

Funakoshi's Christian faith did not lead him to purely biblical art but it did introduce him to camphor wood, the material that he now uses exclusively for his sculpture. Whilst still a student, the young artist received a commission to make a Madonna on condition that the sculpture had to be made of wood. The artist had never worked in this medium before and so followed the advice of his professor to use camphor wood which was relatively easy to carve. Funakoshi has been working with this material ever since as its hardness, smell and colour exactly corresponds to his ideas.

The task of carving a Madonna furthered Funakoshi's familiarity with the imagery of European mediaeval art. He was attracted above all by the œuvre of the sculptor Tilman Riemenschneider (c. 1460 – 1531) whose works are distinguished by the calm precision of their forms and yet appear soft and warm. Funakoshi's works share something of the dignified peacefulness and introspection of the sculptures by the German master which is clearly visible in the clarity of form and fine execution of the faces of his sculptures.

Two very different worlds collide with the contrasting religious concepts of the Far East and Europe. The religions of Japan are characterised by polytheism, a continuity between the divine and man together with an optimistic view of human nature contained within a cyclical notion of time as well as a group-oriented ethic focused on social integration. This is opposed to the Christian world with its monotheism, the separation of the divine and man with the view of man as a sinner leading to a Last Judgement contained within an inwardly-directed ethics who focuses on the individual that in the end has to face God alone.

Japan – Unity and Contrasts

Although Funakoshi's upbringing and his religion may have exposed him to some Western influences, he lives in a country where only one or two percent of the population are Christians. Apart from the lack of national identity often discernible in his works, at the same time they also display several specifically Japanese elements: deepest silence, introspection and passivity. These originate from the Japanese philosophies of Shinto and Buddhism according to which enlightenment is not reached through activity but through quiet introspection and patience. Although this does not exclude the joyful celebrations of Buddhism, rather it is the calm and composed elements that are much more prominent. Furthermore the artist establishes a link with the ancient Japanese tradition of the Kamakura period (1185 – 1333) through his use of eye inserts already referred to.

Shinto and Buddhism, philosophies which are largely alien to the Western mind are the main religious influences in Japan. And yet Japan is also a country that is one of today's leaders in technical developments. Some parts of Tokyo, with their neon lights and hectic streams of people, seem almost more American than America itself. But also still a quiet, 'old-fashioned' world still exists. No worker, for instance, would begin to use a piece of machinery to construct a building before a ceremony has been performed to calm the earth-spirits which might be disturbed. Thus, the very ancient and the very modern coexist side by side.

A stranger will notice the strong external reserve of the Japanese exemplified, for instance, by the behaviour of the commuters in the underground trains in Tokyo during rush hour. Despite the close physical proximity of others, the individual is isolated according to an unwritten code of behaviour whereby eye contact is avoided. Instead their eyes focus on the advertisements displayed in the trains or they are closed or their gaze roams aimlessly into the distance. Their faces are calm and expressionless. Looking at the works of Funakoshi one can find a similar, stoical quietness on the faces with a gaze that also wanders indefinitely into the distance. Curiously when groups of Funakoshi's sculptures are installed together a corresponding isolation of the individual manifests itself. The sculptures are usually shown with relatively large distances between them so that their spatial arrangement already prevents their perception as a group. Even if the figures stood closer together each would nevertheless be on its own as they look neither at each other nor their beholder. Their eyes do not focus on anything even if they look straight ahead. Each of Funakoshi's figures gazes into its own world and is thus clad with a cloak of isolation. The strong restraint in the expression of feelings also corresponds to the Japanese tradition of self-control which stems from the warrior ethics of the Samurai and Confucianism.

The Assimilation of Different Influences: An age-old Japanese Tradition
Japan has developed a special tradition of assimilating very different influences. Based on its geographic location as an island – Japan was distant enough to escape occupation but also near enough to the Chinese continent to be shaped by its very diverse influences on religions and art forms. The country has fluctuated between periods of great openness to the outside world and times of complete isolation. Over the centuries the Japanese have become adept in absorbing many influences from the outside and then transforming them into something 'Japanese'. During the Meji period from the middle of the last century the art of Western 'modernism' was introduced to Japan together with such concepts as 'originality' and 'individual creativity' that had been unknown until then. Previously, and for much of the 20th century, Japanese art had been shaped first and foremost through a very strong master-pupil relationship. The aim was to always attain the ability of the master and not so much to create something completely new. With Japan's opening towards the West this very group or master orientated art was joined by something much more individualistic. Funakoshi himself stands between individuality and unity: he both creates individuals but at the same time they express the whole of humanity. Even when Funakoshi's sculptures refer to his personal friends or experiences this is not made obvious for in Japan an expressionistic artistic attitude is rather unusual. If it does occur, purely personal or autobiographical references are avoided. His expressive works transcend the individual or even a culture, instead they reveal universal human problems and experiences.[1]

Funakoshi's View of Man
The motivation to express oneself purely in figurative terms and with reference to man is best conveyed in Funakoshi's own words:
'Meet a far-sighted person.
He walks on narrow city streets but what he sees is the vast space between mountain peaks. Does he see

a great bird spreading its wings, or a dark forest in the distance? Perhaps he's looking at that part of himself that lies farther away than anything else in this world. Indeed, it seems to me that one cannot see farther than inside oneself.

Maybe that's why I sense a certain kinship between the eyes of desert nomads and fishermen and the eyes of philosophers. People with such eyes are rare, but they can be found in all walks of life. Without warning, they pass before me. I cannot call to them - I can only struggle to see them and hear their softly spoken words. To me, their gestures and their eyes somehow embody the humanity in all of us.

Some people say that in knowing oneself one may know the world. The words to express this world are already present within each of us, and our job is to search them out and read them one by one. All of this seems very important to me.

If I am able to see the world clearly by looking within myself, then I can make a statement concerning human existence through the depiction of a single person. Because I feel this way, I shall continue to work with the human form.' [2]

Not only Funakoshi's intense interest in man is being expressed here but also the significance he attributes to the eye. The poetic and dreamlike wording of the text recalls the titles of his works which are subject to a poetry of their very own. Funakoshi's words do not provide an interpretation of his work but rather are an expression of his motivation and how his ideas are formed.

Funakoshi clearly puts man in the centre. He wants to fashion human figures that both reflect their environment and its atmosphere. Attention is focused on the individual. Man as the centre of the universe is opposed to the Japanese view of the world whereby man is just one element in the universe. It is interesting that Funakoshi's also refers to Novalis' novel 'Heinrich von Ofterdingen' where the search for the 'blue flower' leads into the subconscious. He remembers the words of the girl at the spinning wheel: 'Ein jeder lebt in Allen and all' in Jedem auch' ('Each one lives in everyone and everyone also in each one') and 'Who knows the world?' the Sphinx asks the girl who replies, 'He who knows himself'. [3]

But there is also the Japanese element: the individual may well search within himself but also stands at the same time for the larger whole. Representations of individuals do of course exist in Japanese art, especially as part of the tradition of Buddhist sculpture, but there man is not searching for himself but rather is a master who imparts a higher teaching.

The Portrait in the Art of the Far East

Funakoshi's works are images of human beings. For in most cases the term portrait is inadequate as the sitter is not usually identified in the title nor provided with any distinguishing attribute. The titles of representations of Buddhist priests also suggest that they do not portray a particular person but are about more than external similarity, what matters is their aura. For not only is the recording of the external appearance of the depicted person important but also the teaching conveyed through them. From 400 A. D. onwards it was emphasised that the main role of a portrait was the 'transmission of the spirit' and 'later the priority was constantly stressed to place spiritual and psychological truth before merely optical appearance. For the assessment of a work of art the Chi'i-yün schen t'ung of Hshieh Ho (5th century) alone was important: to represent the aura or breath of the movement of life itself.' [4]

During the Kamakura period, Japanese wood sculpture made decisive step towards realism. With the emergence of the 'Pure Land Buddhists' during this time a change from the adherence of the written towards the spoken word of the individual priest took place. He and his teachings gained in importance and thus many portraits of monks and priests were created. The works of this time captivate their audience through their aura of introspective tranquillity. They convey the belief that enlightenment will not be achieved through activity but will only be given to those that are truly calm and patient. Optical resemblance to the depicted individuals is therefore unimportant. This spiritual aspect is also apparent

in Funakoshi's works which function independently from their representative nature. What is depicted above all is a human being but in a complete sense.

Some of Funakoshi's sculptures are based on models but sometimes their facial features spring from his imagination. Some works are accurate portraits and are very close to the model, but occasionally the artist combines two photos or amalgamates different elements into to an imaginary face. Only two works by Funakoshi are clearly marked as portraits: 'Portrait of my Wife' (1981) and 'Portrait of Nakano' (1982).

The Eye: Window to the World and into the Core of Man

It is the eyes which provide Funakoshi's works with their mysterious liveliness. They seem to be directed both inward and outward and thus irritate the onlooker and capture his attention. In most cases the eyes of Funakoshi's figures are not focused on anything just like the eyes of somebody lost in thought, looking inward.

Influenced by the sculptures of the Kamakura period, Funakoshi used eye inserts made from marble for the first time in 1982. Traditionally a crystal sphere backed with paper or silk with the pupil and the iris painted on were used as eyes. Short threads were interposed between paper and crystal to give the impression of the fine blood vessels in the eye. This then is another characteristic feature Funakoshi has taken from the ancient sculptures of his country for he uses the same technique with marble of insetting and fixing the eyes as Japanese sculptors used in the 12th to the 14th centuries.

Eyes are 'windows' to the world and at the same time into the core of the human being. The particular importance of eyes is also apparent in the history of sculpture. The various ways of fashioning the eye range from eyeballs into which iris and pupil are carved to give them a more lively gaze through to painted eyes or inserted eyes of numerous designs. Among these methods the Japanese technique has a particular status: Greek statues had enamel or metal eyes, Egyptian sculptors used painted stones and some Chinese examples show the use of a black stone inserted as pupil but only the Japanese formed eyes out of transparent crystal material backed with silk or paper. Just how much the eye is regarded as being connected with life was demonstrated at an eye opening ceremony performed in the 8th century in Japan. At the inauguration of the Todai-ji Temple of Nara the eyes of the Buddha sculpture were painted in by an Indian monk which was supposed to bring the sculpture to life.[5]

The Use of the Bust for once not as Representation of the Intellect Alone

The classical form of the bust confines the representation of the human being to the head and part of the upper body. Generally in painting which always represents just a section of reality, the limitation of a person to just their bust does not appear to be an unusual reduction. However, in sculpture, the bust shape cannot help but cut off the wholeness of the body. With this focus on just one part of the body the distance between the work of art and nature becomes more distinct. The restriction of the sculpture to the head and its torso of varying depth draws the viewer's attention to man as spiritual being. Thus the sensual moment makes way for the intellectual.

The particular bust form used by Funakoshi is different in that it reaches to just below the navel. He chose this form because the classical bust seemed to be limited too much just to the character and the intellect of a person. For Funakoshi the face alone does not convey a full presence but this he achieves with a bust that is elongated beyond the customary classical dimensions.

With the elongated bust Funakoshi creates a figurative form that is between spirituality and corporeality. Funakoshi's sculptures stand on the narrow dividing line between reality and the sublime, between life and art. Neither the medium nor the traces of his workmanship are concealed. If the dress was too smooth the sculptures might resemble display dummies, an impression that would be further emphasised by their contemporary clothes. However, it is precisely this particular form of bust that liberates his fig-

ures from direct reality. A full-figure sculpture is closer to reality (more 'real'), as it has, so to speak, both feet firmly on the ground.

The Title as an Entrance to another World

Simple and unambiguously descriptive titles are rare in Funakoshi's work. Usually his titles are poetic or even mysterious. It is characteristic that none of the titles make it possible to guess whether a real person is portrayed or one worked from his imagination. It is one of Funakoshi's intentions to lead the viewer into the world of the figure that he has created. He wants us to see more than just the external appearance. The titles come into being after the work has been finished, like choosing the name of a child.

'Number of Words Arrived' and 'Number of Words Unarrived' are the titles of portrait busts of the British sculptor Anthony Caro chosen by Funakoshi because Caro always has new ideas which have the potential to be converted into works of art. However, it is not possible to realise all the ideas, thus: 'Number of Words Arrived' (ideas transformed into works) and 'Number of Words Unarrived' (ideas not realised).

Although the titles of Funakoshi's sculptures do not appear to be connected by a common theme, some words such as 'water', 'words' and 'mountain' stand out because they are used more often. The word 'water' first appears in the title of the sculpture 'Staying in the Water' of 1991. It came from the artist's memory of an experience in the swimming pool: completely alone in the pool he remained under water as long as he was able to hold his breath looking around him through his goggles. He felt this to be some kind of self-discovery.

From the year 1994 the word 'mountain' appears more often in the titles. The use of this likewise refers to a personal experience of the artist. Whilst still a student Funakoshi saw a mountain from his university. One day it occurred to him that the mountain in all its magnitude exists in man himself. Consequently works with a seemingly massive torso evolved which alluded to the mountain. This development can also be seen as a move away from the purely figurative toward more conceptual works.

Silence instead of Expression

What is particularly striking about Funakoshi's sculptures is the expression of silence they convey with their impassive facial expressions and the lack of narrative gestures together with the feeling of timelessness. They confront the viewer with their corporeality and in this sense they inhabit our immediate world. Their calm, collected gaze, however, then seems to lead into another realm, another time. Funakoshi deliberately chooses a rather undefined (vague) expression for his figures. He believes that everything can be expressed in silence – whether crying or laughter. In addition to the concentrated facial expression of the sculptures, their gestures are reduced to the minimum. The lack of gestures stems from the absence of hands in most busts. The more neutral the gesture the less certain the general impression of the work becomes which in turn provides greater scope for the imagination of the viewer. Silence becomes the source of spiritual movement.

Less is More

The poetically mysterious titles and the reduced yet very rich expression of Funakoshi's figures remind one of Japanese poetry. Waka (31 syllables) and Haiku (17 syllables) are the names of the short, and for the Western observer often seemingly meaningless, Japanese poems. The Waka tries to create a web of associations with the aid of words, allegories, metaphors and similes. The overall impression of the whole with the resulting web of associations could be understood as a 'field' where time stands still or is abolished since the meaning of all the words is present in one single sphere at the same time.[6]

A Haiku of the poet Bashô (1644 – 1694) demonstrates the range of meanings that can be conveyed in

just a few words. Furthermore its mood corresponds to Funakoshi's sculptures and illustrates the relation of his work to Japanese culture:

furuike ya	the quiet pond
kawazu tobikomu	a frog leaps in
mizu no oto	the sound of water [7]

This Haiku is usually regarded as an example of the manifestation of eternity and peace. Zen followers see it as a symbol for immediate wisdom. Eternity, infinite space or endless time can also be imagined in silence. However, one only becomes aware of this state of the infinite once it is interrupted by the sound of water moving by the leap of the frog. This is based on the principle of oppositions: silence cannot be discerned without the knowledge of noise, just as the concept of unlimited time relies on the existence of the moment. Applying these principles to Funakoshi's work one could say that the expression of time-lessness only gains validity through the brief passing presence of the viewer.

The Work of Art as an Appeal for Self-Contemplation

Funakoshi integrates the diverse worlds as those of the Far East, Europe and America into his work as a whole. He creates sculptures of human beings which are not necessarily defined by their national identity. Their nationality is irrelevant, what is important is the gaze into the depth of the self in search of the stone of wisdom at the bottom of their inner sea. This search is seen in the expression of deep calm and timelessness of Funakoshi's figures. 'The work of art is an appeal for self-contemplation in that it lifts the viewer from his sphere of daily life and transports him into another world – he is 'enchanted'. To understand therefore means to recreate oneself in front of the work of art. This is the root of art and its spiritual affinity with religion ...' [8]

1 Cf. Janet Koplos, *Japan. Contemporary Japanese Sculpture,* New York/London/Paris 1991 (= Abbeville Modern Art Movements), p. 16

2 Funakoshi, in cat. *XX Biennal de São Paulo 1989 Japão,* The Japan Foundation, 1989, p. 18

3 Novalis, *Das dichterische Werk; Tagebücher und Briefe,* ed. by Richard Samuel, Munich/Vienna 1978 (= Novalis. Werke, Tagebücher und Briefe Friedrich von Hardenbergs, ed. by Hans-Joachim Mähl und Richard Samuel, vol. I), p. 351 and p. 357

4 Danielle and Vadime Elisseeff, *Japan. Kunst und Kultur,* transl. by Hedwig and Walter Burkart, Axel Küchle, Monika Marutschke und Brigitte Weiss, 2nd edition, Freiburg/Basle/Vienna, 1987, p. 173

5 Cf. Nishikawa Kyotaro, 'Japanese Buddhist Sculpture', in cat. *The Great Age of Japanese Buddhist Sculpture. AD 600 – 1300,* Nishikawa Kyotaro, Emily J. Sano, Kimbell Art Museum, Fort Worth and Japan House Gallery, New York, Kyoto 1982, p. 24

6 Cf. Izutzu Toshihiko, *Die Theorie des Schönen in Japan: Beiträge zur klassischen japanischen Ästhetik,* ed. by Franziska Ehmcke (transl. from English and Japanese by Franziska Ehmcke), Cologne 1988, p. 13

7 Faubion Bowers, *The Classic Tradition of Haiku, An Anthology,* New York 1996, p. 15

8 Gerhard Frey, 'Zur Deutung des Kunstwerks' (1958), originally published in Gerhard Funke (ed.) *Konkrete Vernunft, Festschrift für Erich Rothacker* (for 12 March 1958), Bonn 1958, pp. 377 – 394, in Dagobert Frey (ed.), *Bausteine zu einer Philosophie der Kunst,* Darmstadt 1976, pp. 83 – 112

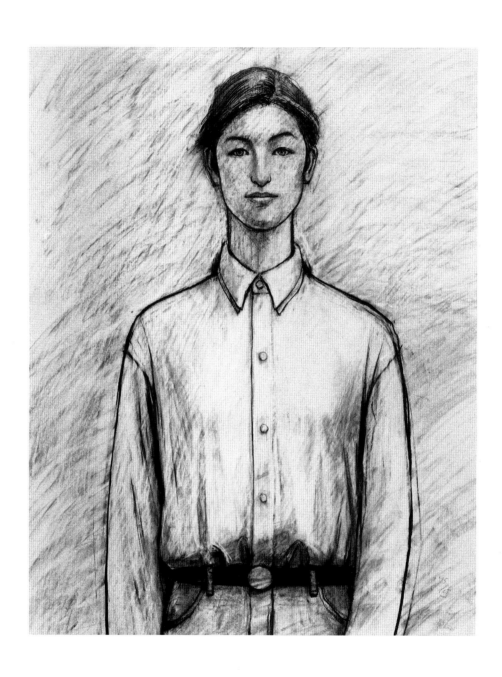

Drawing for 'Map of Water', 1995
Map of Water, 1995

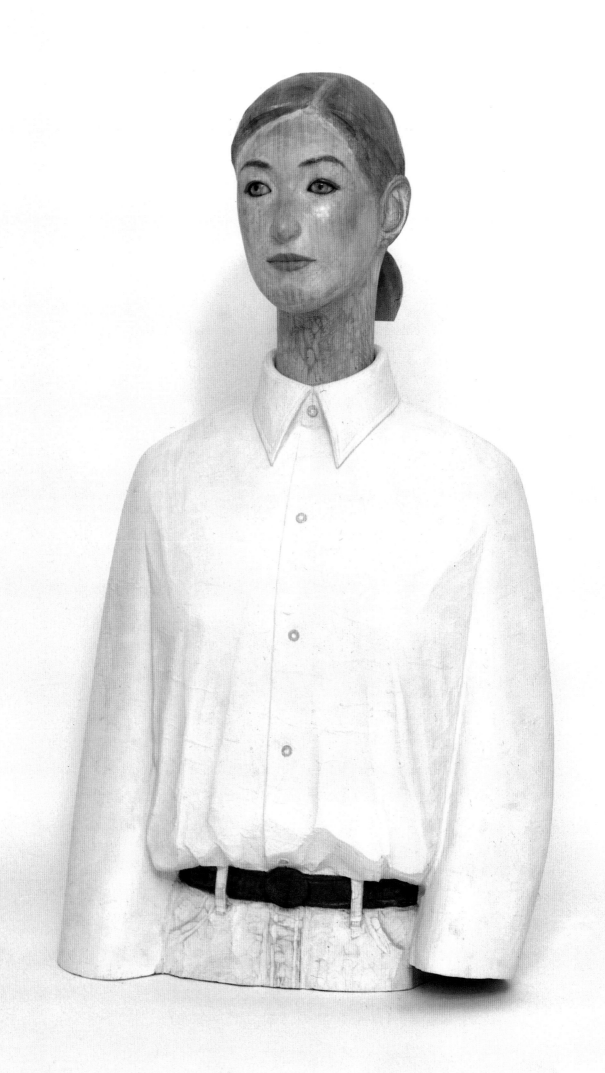

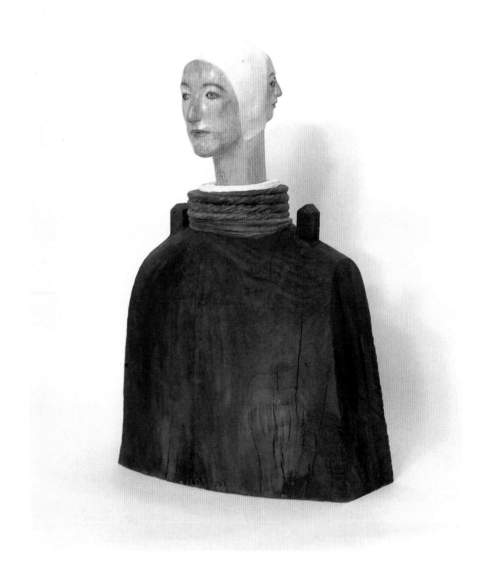

The Moon on the Northermost, 1995

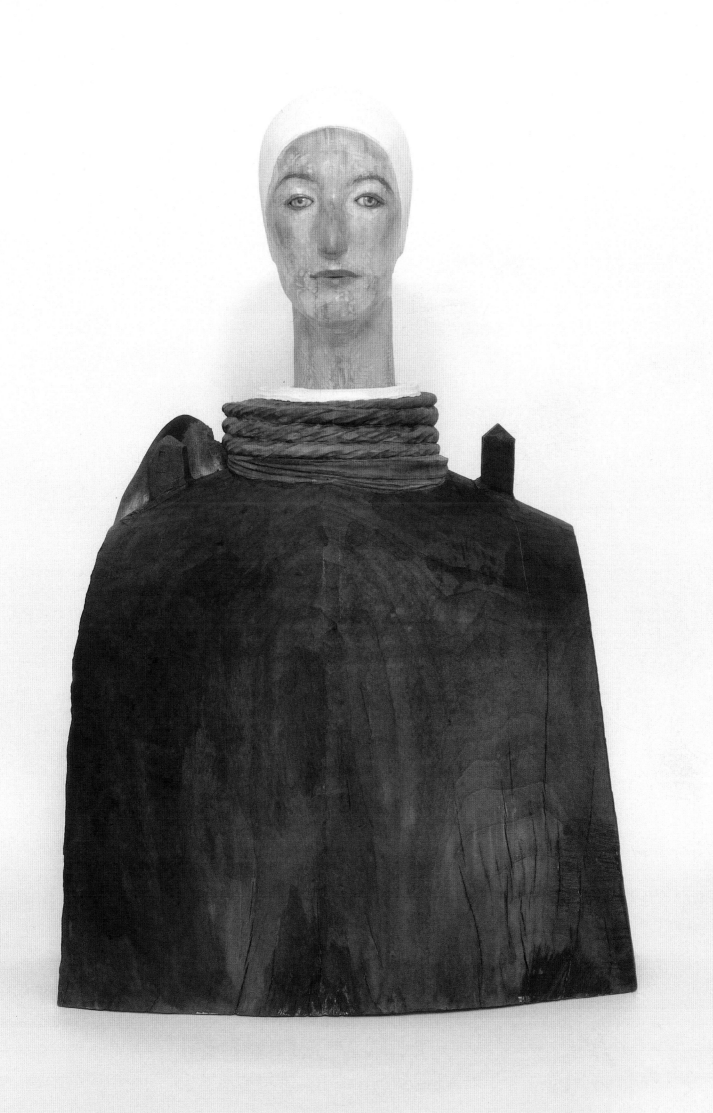

Dieter Brunner

„ ... nicht zu hart und nicht zu weich"
Kampferholz – das Material der Skulpturen Funakoshis

I. Mythos Baum

Das Wissen um die vielfältige symbolische Bedeutung des Baumes ist ein wichtiger Ansatz für das Verständnis im Umgang mit dem Material Holz: Der Baum zählt zu den ältesten und in fast allen Kulturen anzutreffenden Archetypen der Menschen. Das Urbild des Baumes, der Weltenbaum, dessen Krone in den Himmel und dessen Wurzeln tief in die Erde reichen, ist als bildliche Vorstellung der Welt in vielen Völkern beheimatet. In Religion, Kunst, Märchen und Sagen, Rechts- und Volksbräuchen spielt der Baum eine wichtige Rolle.[1] Wir kennen Bäume als Versammlungsorte für Feste, Gerichtsverhandlungen, Richt- und Todesstätten. Nach vielen Schöpfungsmythen stammen die Menschen von Bäumen ab.

Als heilige Stätte ist der Baum in nahezu allen Religionen und Kulturen bekannt: Als Wohnort der Götter und Geister sind z. B. im antiken Griechenland Haine und Wälder bevorzugte Kultstätten. Erweitert wurde die Vorstellung von der Heiligkeit der Bäume durch den Glauben, daß Bäume durch ihr Wachsen, ihre jahreszeitlich bedingten Veränderungen und ihr Absterben wesensgleich mit den Menschen seien und wie diese eine Seele besäßen. Durch Opfergaben, Kränze und andere Weihegeschenke wurden diese Bäume besonders verehrt. Der blühende, immergrüne Baum gilt als Symbol des Lebens und der Lebenskraft, dessen Früchte Gesundheit, Jugend und Ewiges Leben verleihen. Der Schöpfungsbericht des Alten Testaments siedelt den Baum des Lebens in der Mitte des Paradiesgartens an. Auch der Baum der Erkenntnis des Guten und des Bösen steht im Paradies. Er ist dem Symbolbereich des Baumes der Weisheit zugeordnet. Nach der Überlieferung werden Prophezeiungen und Hilfestellungen durch Bäume vermittelt oder die Stimme Gottes ist im Baum zu vernehmen.

Viele dieser Vorstellungen haben Entsprechungen in den japanischen Religionen. Die Naturverehrung ist ein wichtiger Aspekt des Shintoismus, der einheimischen Religion Japans. Der immergrüne Sakak-Baum und der Hinoki-Baum sind die heiligen Bäume des Shintoismus, man wähnt sie mit einem Geist beseelt. So gehört beispielsweise zum Kult des Shintoismus die Darbringung von Zweigen des Kirschbaums. Ursprünglich galten in Japan Wälder als Sitz der Gottheit, weshalb man keine Tempelbauten errichtete. Später diente als Kultstätte für den Shinto-Gottesdienst ein von Bäumen umgebener Platz.

Der Buddhismus übernahm den Baumkult der älteren Religionen, allerdings mit dem Unterschied, daß nicht mehr der Baum selbst als heilig verehrt wurde, sondern die Gottheit, die ihn bewohnte. Der Bodhisattva Siddharta (ca. 560 – 480 v. Chr.), der Gründer des Buddhismus, erlebte alle wichtigen Stufen seines Lebens als Buddha unter einem heiligen Baum: Geburt, erste Meditation, Erleuchtung unter einem Bodhi-Baum, der von den Buddhisten schon zu Lebzeiten Buddhas verehrt wurde, und Tod.[2]

II. Funakoshi und die Holztraditionen in Japan und Europa

Funakoshi knüpft an eine lange Tradition der Auseinandersetzung mit dem Werkstoff Holz in Japan an. Architektur ist bis heute überwiegend aus Holz gefertigt, sowohl die profanen als auch die sakralen Bauten. Auch die Tradition der Holzskulptur reicht in Japan weit zurück. Sie findet sich vor allem in der buddhistischen Religion. Seit der Heianzeit (8. – 12. Jahrhundert) wurde Holz zum bevorzugten Werkstoff. In dieser Zeit entstanden die Grundlagen der für Japan typischen Formen und Techniken für Holzplastiken wie

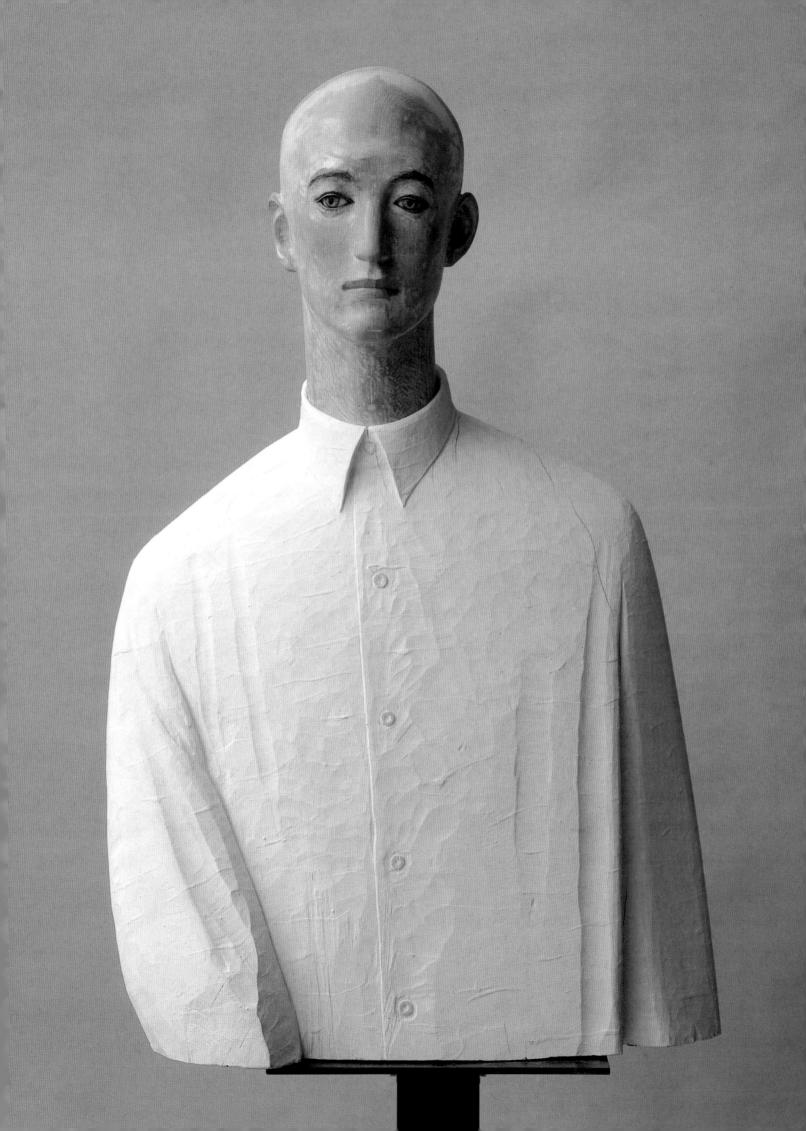

die Aushöhlung des Holzkerns und das Zusammensetzen sorgsam ausgewählter Holzblöcke. Begeistert war Funakoshi von den lebensvollen Freiplastiken der Kamakura-Zeit (1185 – 1333). Die realistische Porträtkunst dieser Kultur hatte zwei Themen: muskulöse Wächterkönige und die großen Lehrer des Zen-Buddhismus. Die formstrengen Porträts waren aus verleimtem Holz geschnitzt, Kristalle wurden als Augen durch den Hinterkopf eingesetzt, eine Technik, die Funakoshi in seinen Porträts wieder aufgriff und weiterentwickelte.

Sicher lag der Hauptgrund für die überwiegende Verwendung von Holz in Japan darin, daß den Künstlern so gut wie keine anderen Materialien, wie z. B. Stein, zur Verfügung standen. Aber nicht nur die Verfügbarkeit spielte bei der Wahl wohl eine Rolle, sondern auch die Beziehung zum Material, seine Ursprünglichkeit, seine Vitalität, seine Ausstrahlung, seine heilige Aura.

Wichtiger Bezugspunkt für Funakoshi ist aber auch die abendländische Kunst. In der europäischen Kunstgeschichte hat Holz als künstlerisches Material eine weit ins Mittelalter zurückreichende Tradition und konzentriert sich vor allem auf den Bereich nördlich der Alpen. Hauptaufgabenfelder der Holzbildhauerei, die ihren Höhepunkt in der Gotik erreichte, waren Madonnenstatuen, Kruzifixe, Triumphkreuzgruppen, Andachtsbilder und insbesondere die Schnitzaltäre des 14. und 15. Jahrhunderts. Durch seine Religionszugehörigkeit zu den Katholiken, einer Minderheit in Japan, ist Funakoshi seit seiner Kindheit mit solchen christlichen Bildthemen vertraut. Westliche Elemente vermittelte ihm aber auch sein Vater Yasutake Funakoshi, dessen figürliche Werke aus Bronze und Marmor von europäischer Skulptur, insbesondere von Auguste Rodin, angeregt sind.

Katsura Funakoshi kommt in der zeitgenössischen Holzskulptur Japans eher eine Sonderstellung zu. Das Holz ist in Japan weiterhin ein wichtiges Material, es hat vor allem bei den abstrakten Bildhauern eine große Bedeutung. In Europa wird das Holz – bedingt durch die Neubewertung außereuropäischer Skulptur – zu Beginn des 20. Jahrhunderts durch Künstler des Expressionismus und des Kubismus wiederentdeckt, nachdem es lange Zeit als Kunstmaterial verpönt war. In der weiteren Entwicklung der europäischen Holzskulptur spielt auch Henry Moore ein wichtige Rolle, der die dem Material innewohnenden Qualitäten stärker in den Vordergrund stellte. Seit Beginn der 80er Jahre erfreut sich das Holz bei den zeitgenössischen Bildhauern wieder zunehmender Beliebtheit. Auftakt für diese Renaissance war die eindrucksvolle, mit einem Beil bearbeitete, grob bemalte Holzskulptur von Georg Baselitz auf der Biennale 1980 in Venedig. Vor allem in Deutschland haben sich Bildhauer seit dieser Zeit der Holzskulptur zugewandt – die Kettensäge hat den Stechbeitel als wichtigstes Werkzeug in der Holzskulptur längst abgelöst: Karl Manfred Rennertz, Rudolf Wachter, Stefan Balkenhol seien als zeitgenössische Beispiele in Deutschland genannt. In anderen Ländern Europas gibt es vereinzelt Sonderstellungen von Holzbildhauern: z. B. David Nash in England oder Giuseppe Penone in Italien.

III. Die Materialgerechtigkeit – ein Dogma des 20. Jahrhunderts
Bis weit ins 20. Jahrhundert fand der Bildhauer die Form aufgrund einer Idee, das Material spielte bei der Formfindung eher eine untergeordnete Rolle. In der gotischen Skulptur wurde das Material lange Zeit gar so weit zurückgedrängt, daß es nicht mehr zu sehen war. Die Schnitzarbeit war sozusagen lediglich die erste Phase, der Untergrund. Seine Weitergestaltung erfuhr der gotische Altar erst durch die abschließende Faßmalerei, in der die Oberfläche nicht nur bemalt, sondern weiter verfeinert wurde.[3] Seit Ende des 15. Jahrhunderts gab es in der Geschichte der Holzbildhauerei Künstler, die dem Material zunehmend einen eigenen Wert zuschrieben. Die bewußte Abkehr von der farbigen Gestaltung und die stärkere Beachtung des Materials Holz begann mit Künstlern wie Tilman Riemenschneider und Veit Stoß.

Zu Beginn des 20. Jahrhunderts spielen in der Holzplastik die Spuren des Werkzeugs, die Bearbeitungsspuren von Stechbeiteln und anderen Geräten eine wichtige Rolle. Diese Strukturen betonen die Beteiligung des Materials am Formfindungsprozeß, dem Holz wird eine weitergehende künstlerische

Bedeutung zugedacht. Der Begriff „Materialgerechtigkeit" wurde im 20. Jahrhundert insbesondere von Henry Moore – vor allem in seiner Frühzeit – hervorgehoben: „Jedes Material hat seine individuellen Eigenschaften. Nur wenn der Bildhauer unmittelbar arbeitet, wenn eine aktive Beziehung zu seinem Material besteht, kann dieses Material an der Gestaltung der Idee teilhaben. Stein z. B. ist hart und dicht und sollte nicht dazu verfälscht werden, daß er aussieht wie weiches Fleisch ..."[4]

„Die Form folgt dem Material"[5] war eine in der Nachfolge von Henry Moore geäußerte Doktrin – vor allem in der Bildhauerei der Nachkriegszeit. In dieser Zeit war Henry Moore längst von dieser Auffassung abgerückt: „Ich halte die Materialgerechtigkeit immer noch für überaus wichtig, habe aber früher die Bedeutung überschätzt."[6] Die zeitgenössische Holzplastik setzt häufig diese Tradition fort, welche die dem Material innewohnenden Qualitäten berücksichtigt und zur Geltung kommen läßt. Sehr häufig entstehen Plastiken aus dem Werkstück und dessen Struktur heraus: Das Material ist mit Ausgangspunkt des plastischen Konzepts und bestimmt den Arbeitsprozeß.

Auch Funakoshi ist von diesen europäischen Vorstellungen des 20. Jahrhunderts in seiner künstlerischen Arbeit nicht unbeeinflußt geblieben, selbst wenn er sich für ein künstlerisches Arbeiten, in dem die Idee der zu gestaltenden figurativen Skulptur Priorität hat, entscheidet. Meist formuliert er seine Vorstellung von der Büstenform, von ihren Proportionen und ihren Formverläufen in vorbereitenden Skizzen. Trotz der farbigen Bemalung erhält Funakoshi aber die Holzsichtigkeit der Büste: Die starke Maserung scheint durch die zarte Bemalung hindurch, gelegentlich – wie bei der Haut – verzichtet Funakoshi auch fast ganz auf Bemalung. Darüber hinaus bezieht der Bildhauer die unterschiedlichsten für das Holz typischen Bearbeitungsspuren vom groben Abkanten bis hin zum feinen Schleifen und Polieren mit ein. Ebenso beachtet er Materialprozesse, die das Holz auch noch nach der Fertigstellung erfährt: Insbesondere integriert er ganz bewußt die Sprengkräfte des Holzes, sei es, daß er, wie beim Körperteil, Rißbildungen geradezu provoziert oder daß er sie, wie beim Kopfteil, ganz bewußt vermeidet. Die Bedeutung des Materials für die Formfindung zeigt sich in einem Satz Funakoshis: „Das Material, das ich verwende, ist wichtig, es beeinflußt das Ergebnis. Ich suche nach der vollkommenen Spannung zwischen dem Material und der Bildvorstellung."[7]

IV. Funakoshis Arbeit am Holz

Seit 1977, als Funakoshi als gerade diplomierter Künstler den Auftrag erhielt, für das Trappistenkloster in Hakodate eine Madonna mit Kind in Holz zu fertigen, arbeitet er mit dem für ihn damals neuen Kampferholz, zu dem ihm ein Professor seiner ehemaligen Universität riet.

Der Kampferbaum ist ein Lorbeerbaum, der in China und Japan verbreitet ist und bis zu 40 m hoch werden kann. Seine Blätter werden in der Medizin zur Herstellung von Anregungsmitteln für Herz und Atmung verwendet. „Kampferholz ist nicht zu hart und nicht zu weich", schwärmt Funakoshi, „es riecht angenehm, und die Farbe ist gerade so wie die Haut von Japanern, nicht zu weiß und nicht zu braun. Als ich saß und Monat um Monat an der Madonna arbeitete, da wußte ich: Das ist mein Holz."[8] Für den Auftrag studierte Funakoshi die christliche Bildkunst und entdeckte als Vorbild Tilman Riemenschneider wieder, dessen Motive ihn schon in seiner Kindheit begleiteten.

Mit der Holzbüste „Portrait of my Wife" von 1981 hat Funakoshi die erste in Form und Ausdruck endgültige Formulierung seines Themas gefunden: „den Menschen, der alle Menschen in sich vereint und doch einzig ist."[9] Hier tauchen zum erstenmal die überlängte Büstenform und der klare, unnahbare Gesichtsausdruck auf. Kennzeichnend werden für die folgenden Holzfiguren die eingesetzten Marmoraugen, poetische Titel, eine polychrome Bearbeitung und bis Anfang der 90er Jahre eine alltägliche Bekleidung, später dann auch mönchsähnliche Gewänder und Kappen, die an Kopfbedeckungen der italienischen Renaissance erinnern.

Funakoshis Holzfiguren entstehen in mehreren Arbeitsschritten.[10] Nach vorbereitenden Zeichnungen fertigt Funakoshi die Skulptur in zwei separaten Teilen: Körper und Kopf. Beim Kopf beginnt er mit der

Kettensäge. Die so entstandene kantige Büstenform verfeinert er mit grobem Schnitzmesser und nimmt dabei immer wieder zeichnerische Korrekturlinien zu Hilfe. Die Augen bleiben lange im Holz erhalten, sie werden durch dunkle Farbe gekennzeichnet: Für das weitere Vorgehen sind sie sozusagen Fixpunkte. Durch das Auftragen einer weißen Schicht und das anschließende Wegschleifen und Polieren erhält Funakoshi eine Farboberfläche, die der menschlichen Hautfarbe sehr nahe kommt. Erst ganz zum Schluß setzt Funakoshi die Marmoraugen: Er öffnet den Kopf von hinten, höhlt ihn aus, setzt die Augen ein und verschließt ihn anschließend wieder. Bei der Herstellung der Augen greift Funakoshi auf eine Technik der Kamakura-Periode zurück und modifiziert sie: Er verwendet Marmor, den er bemalt und mit roten Baumwollfädchen versieht und anschließend glänzend lackiert.

Ähnlich wie der Kopf wird auch der Körper der Büste hergestellt. Dieser Teil wird verhältnismäßig grob bearbeitet und meist zart bemalt. Die Farbpalette ist sehr begrenzt. Im Vergleich zum Kopf wird der Körperteil verhältnismäßig grob ausgehöhlt; der Körper bleibt dickwandiger und entsprechend bilden sich in diesem Teil später feine Trocknungsrisse.

Erst nach der Fertigstellung der Einzelteile wird der Kopf in den Rumpfteil eingesetzt. Funakoshi zeigt ganz bewußt die Zweiteiligkeit. Oft sind die Übergänge nicht verschliffen, manchmal sitzt der Kopf nicht ganz fest. Die zusammengefügte Holzskulptur wird auf einen dünnen Stahlstab, der unten eine Standplatte hat, montiert, so daß sich der Kopf in etwa auf Augenhöhe befindet. Gelegentlich fügt Funakoshi reale Teile, wie eine Brille, zu der Figur hinzu.

V. Die Aushöhlung des Holzes

Der mittelalterliche Bildhauer schnitzte den Körper einer Figur aus einem dicken Stamm, auf dem die Umrisse zunächst grob angelegt wurden, die hervor- bzw. abstehenden Teile wurden aus Zeitersparnis und zur Arbeitserleichterung aus separaten Hölzern angefügt und die Übergänge in der Feinbearbeitung kaschiert. Um große Rißbildungen zu vermeiden, wurden die sakralen Standfiguren ausgehöhlt. Dafür halbierte man den Stammabschnitt und entfernte den Holzkern schnell bis auf eine Wandungsstärke von ca. 2–8 cm, so daß das Holzstück schneller und gleichmäßiger trocknen konnte. Die rückwärtige Aushöhlung wurde anschließend mit einem Brett verschlossen.[11]

Auch in Japan ist die Technik des Aushöhlens seit dem 8. Jahrhundert in der buddhistischen Holzskulptur bekannt, d. h., es existieren sowohl blockbelassene als auch von unten oder von hinten ausgehöhlte Holzskulpturen. Eine Sonderform der Holzbearbeitung, die seit dem 11. Jahrhundert perfektioniert wurde, ist die Technik, vor allem große Holzplastiken aus sorgsam ausgehöhlten Einzelblöcken zusammenzusetzen. Im Westen wurde diese Technik erst im 20. Jahrhundert von Künstlern verwendet.

Funakoshi greift im Prinzip auf die Einzelblockbearbeitung zurück. Jeder Teil seiner zweiteiligen Büste ist aus einem einzelnen Block gefertigt und anschließend ausgehöhlt. Ganz bewußt bezieht er die Funktion des Aushöhlens mit ein – als Eingriff in den Trocknungsprozeß der Werkstücke – und nutzt dies ganz unterschiedlich. Sehr dünnwandig und deshalb weitgehend ohne Risse sind die Köpfe. Vergleichsweise grob ausgehöhlt, also dickwandig sind die Körper; Risse sind hier durchaus akzeptiert. Daraus ergibt sich eine Steigerung in der Bearbeitungsperfektion, in ihrer Glätte vom grob bearbeiteten Körper über den glatten Kopf bis hin zu den glänzenden Augen. Über die bewußte Einbeziehung von Glätte und Perfektion, aber auch durch ein zweites Material, den Marmor, wird wie z. B. auch in der Porträtmalerei eines Rembrandt der Blick des Betrachters zu den Augen hingeführt.

VI. Material und Illusion

Holz ist ein Material, das Bedingungen vorgibt, ein Material, mit dem man in Dialog treten muß. Durch seine Struktur hat es nur wenig Neutralität, es hat ganz spezifische Qualitäten, wie z. B. die Einmaligkeit und Unverwechselbarkeit eines einzelnen Holzstücks oder die Widerborstigkeit und Unberechenbarkeit

des gewachsenen Materials. Der Bildhauer ist im Umgang mit Holz zur Partnerschaft und zur Konkurrenz zugleich herausgefordert. Bei diesem Material wird immer deutlich, daß es vitale Strukturen hat, daß es der Natur entnommen ist, auch bei Funakoshi. „Er schrieb, daß, wenn man Holz berührt, dann ist es warm, ganz anders als Stein oder Stahl. Obwohl er es nicht ganz so explizit ausdrückte – Holz ist organisch, es kommt von einem lebendigen Ding, der Prozeß geht ja noch weiter."[12] Das Holz lebt weiter, es arbeitet weiter, es ist natürlich, es ist vergänglich und es ist verletzlich.

Auf die Zusammenhänge von Mensch und Baum ist immer wieder hingewiesen worden, der Baum als „Bruder des Menschen"[13]. So gibt es Analogien zwischen Fuß und Wurzel, zwischen Stamm und Körper, zwischen Zweigen und Armen bzw. Fingern, zwischen Krone und Kopf. Und auch zwischen dem Aufbau der menschlichen Haut und der Rinde bzw. Struktur des Baumes gibt es gewisse Verwandtschaften.

Funakoshi greift auf diese Affinitäten zurück: Den überlängten Körpern seiner Skulpturen bleibt etwas Baumhaftes zu eigen, ganz bewußt verzichtet er fast immer auf die Hände oder gar raumgreifende Gesten. Mit der Oberfläche und der Transparenz des Holzes suggeriert er menschliche Haut, die Maserung erinnert an feine Adern und die Zellstruktur des Holzes an die Poren der Haut. Die Skulpturen von Funakoshi bleiben sozusagen Baum und werden Mensch zugleich. Sie stehen für das gemeinsame Schicksal von Kreatur und Pflanze.

Im Holz artikuliert sich das Prozeßhafte, die Vergänglichkeit – Tod und Leben. Auch Funakoshis Skulpturen schließen die Spannbreite zwischen diesen beiden Polen ein: Mimik und Gestik zwischen verhaltener Bewegung und eingefrorener Pose. Diese Ambivalenz von Zeit und Zeitlosigkeit führt Funakoshi zu einer seltsamen Mischung von Realität und Irrealität: Nah und doch fern, dem Leben entnommen und doch erstarrte Skulptur. Gerade deshalb ist es auch ganz interessant, daß Funakoshi auf die blockhaft geschlossene, archaische Stellung und auf die Frontalität zurückgreift. Die archaische Figur verläßt bei ihm den dauerhaften Stein und schlüpft in das zeitlich begrenzte Holz.

Und doch ist die Dauerhaftigkeit in anderer Hinsicht bei Funakoshi relevant; denn nie möchte er nur einen einzigen Augenblick darstellen: „Es ... schien möglich, das Gefühl zu vermitteln, daß die Figur an meiner Seite war. Ich würde gern menschliche Wesen schaffen, die weiter existieren, auch wenn die Zeit vergeht."[14] Nicht der einzelne Augenblick, sondern die Dauerhaftigkeit, und mit der Dauerhaftigkeit auch die Vergeistigung, sind zentrale Intentionen Funakoshis. Sein Ziel sind stille, entrückte Wesen, „Individuen zwischen Geistigkeit und Körperlichkeit"[15]. Funakoshi beschreitet mit seinen figurativen Skulpturen eine hochgradig riskante Gratwanderung, da Perfektion und Illusionismus sehr schnell ins Banale abgleiten können. Funakoshi erreicht alleine über das Material so viel Naturnähe, daß er die Freiheiten der Gestaltung ausschöpfen kann. Er nimmt dem Illusionismus seine Spitze, indem er beispielsweise selbst beim Gesicht die Bearbeitungsspuren stehen läßt. Und er drängt die körperliche Präsenz und die Lebendigkeit der Figuren wieder zurück durch die fast unbewegte Pose und den entrückten, unnahbaren Ausdruck. Das durch die Marmoraugen ergänzte Holz erlaubt einen ganz anderen Umgang mit der Realität als Wachs und Kunstharz, ein ganz anderes Abrücken vom Abbildhaften, ohne das Naturhafte zu verlieren.

Im Gegensatz zu den Plastiken Duane Hansons sind Katsura Funakoshis Figuren ganz bewußt Kunstfiguren. Sein Interesse gilt der Polarität zwischen Natürlichkeit und Künstlichkeit. Das Artifizielle bleibt in Spannung mit dem lebendigen Abbild; und weil die Figur Kunstfigur bleibt, ist sie viel eindrucksvoller und lebendiger als Kunstwerke der Hyperrealisten, die große Kraft auf Illusion und Täuschung verwenden.

Funakoshi relativiert nicht nur die illusionistischen Aspekte, er schafft Spannungsfelder – ganz im Gegensatz zu Duane Hanson, dessen Figuren er auf einer Ausstellung in Tokio sah. Er war beeindruckt und enttäuscht zugleich: „Es bewegt sich nicht"[16], soll er ausgerufen haben.

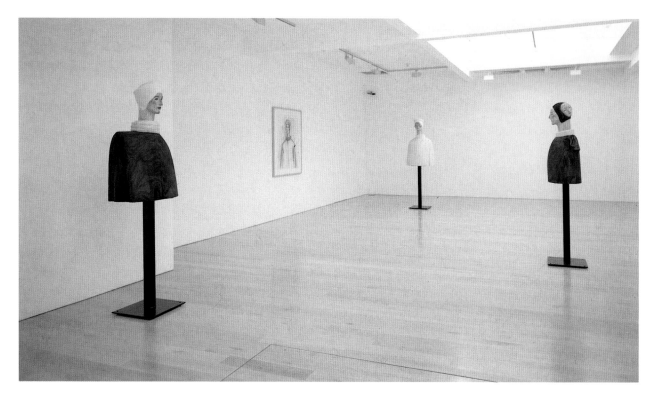

Installation View of the Exhibition 'Reicent Sculpture and Drawings' at Annely Juda Fine Art, 1991

1 Im folgenden vgl. Lurker, Manfred, *Wörterbuch der Symbolik,* Stuttgart 1991, S. 80 f.; Selbmann, Sibylle, *Der Baum. Symbol und Schicksal des Menschen,* Karlsruhe 1984; Gercke, Hans (Hrsg.), *Der Baum in Mythologie, Kunstgeschichte und Gegenwartskunst,* Ausstellungskatalog Heidelberg 1985, S. 52 – 151.

2 Vgl. Gercke, Hans (Hrsg.), *Der Baum in Mythologie, Kunstgeschichte und Gegenwartskunst,* Ausstellungskatalog Heidelberg 1985, S. 63 – 68.

3 Sehr häufig wurden die Werke im 19. Jahrhundert – im Zuge klassizistischer Ästhetik – abgelaugt.

4 Halder, Johannes, Zechlin, Ulrich P., *Henry Moore, Materialsammlung für Kunsterzieher an der gymnasialen Oberstufe des Landes Baden-Württemberg,* o. J., S. 12.

5 Vgl. Bechinie, Anna, *Katsura Funakoshi. Skulptur zwischen zwei Kulturen,* Magisterarbeit, Bonn 1998, S. 66.

6 Halder, Johannes, Zechlin, Ulrich P., *Henry Moore, Materialsammlung für Kunsterzieher an der gymnasialen Oberstufe des Landes Baden-Württemberg,* o. J., S. 14.

7 Funakoshi in einem Interview August 1990 mit Constance Lewallen, Crown Point Press, San Francisco, View, Vol. VII, No. 3, Fall 1990, zitiert nach: Bechinie, Anna, *Katsura Funakoshi. Skulptur zwischen zwei Kulturen,* Magisterarbeit, Bonn 1998, S. 66.

8 Tschechne, Martin, *Katsura Funakoshi. Blicke in die Unendlichkeit der Seele,* in: *Art. Das Kunstmagazin,* Nr. 3, März 1996, S. 24.

9 Ebd., S. 24.

10 Vgl. Bechinie, Anna, *Katsura Funakoshi. Skulptur zwischen zwei Kulturen,* Magisterarbeit, Bonn 1998, S. 68 – 70.

11 Vgl. Westhoff, Hans, *Vom Baumstamm zum Bildwerk. Skulpturenschnitzerei in Ulm um 1500,* in: *Meisterwerke massenhaft,* Ausstellungskatalog Stuttgart 1993, S. 253 – 256.

12 Vgl. Vaizey, Marina, *Number of Words Arrived,* in: *Katsura Funakoshi. Sculpture,* Ausstellungskatalog Annely Juda Fine Art, London 1991, o. S.

13 Gercke, Hans, *Brücke zwischen Mythos und Aktualität. Der Baum in der Gegenwartskunst,* in: Gercke, Hans (Hrsg.), *Der Baum in Mythologie, Kunstgeschichte und Gegenwartskunst,* Ausstellungskatalog Heidelberg 1985, S. 295.

14 Vgl. Vaizey, Marina, *Number of Words Arrived,* in: *Katsura Funakoshi. Sculpture,* Ausstellungskatalog Annely Juda Fine Art, London 1991, o. S.

15 Vgl. *Funakoshi,* in: *Today's Artists V–´93,* Museum of Modern Art, Kamakura, S. L – L.I.

16 Tschechne, Martin, *Katsura Funakoshi. Blicke in die Unendlichkeit der Seele,* in: *Art. Das Kunstmagazin,* Nr. 3, März 1996, S. 25.

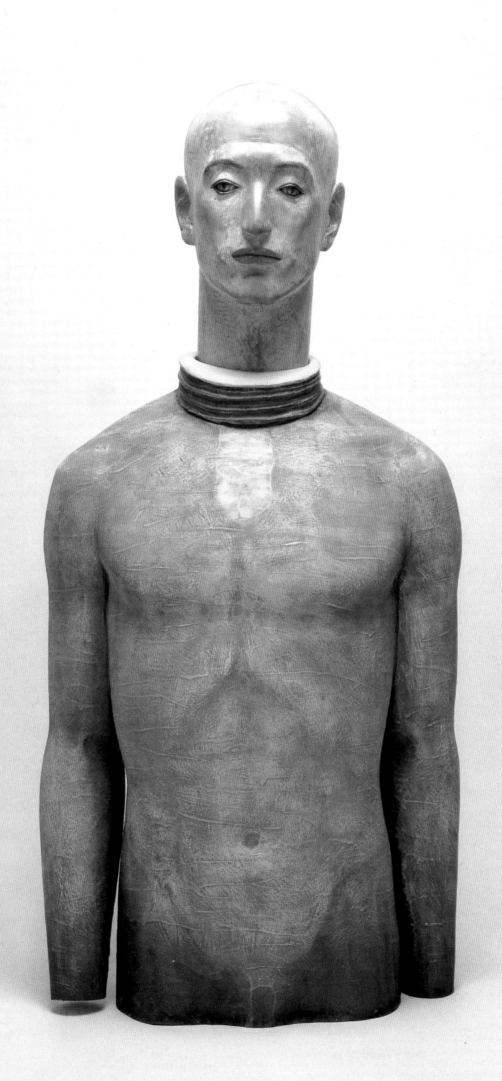

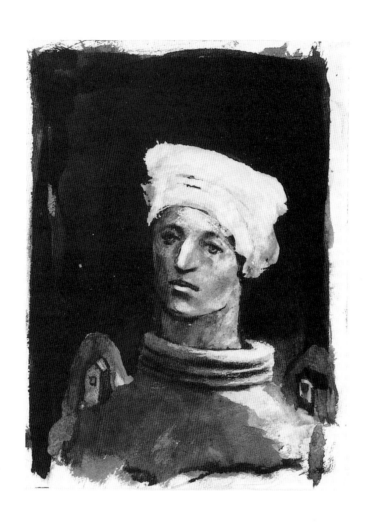

Drawing 9531, 1995
Fragments of Pale Mountain, 1995

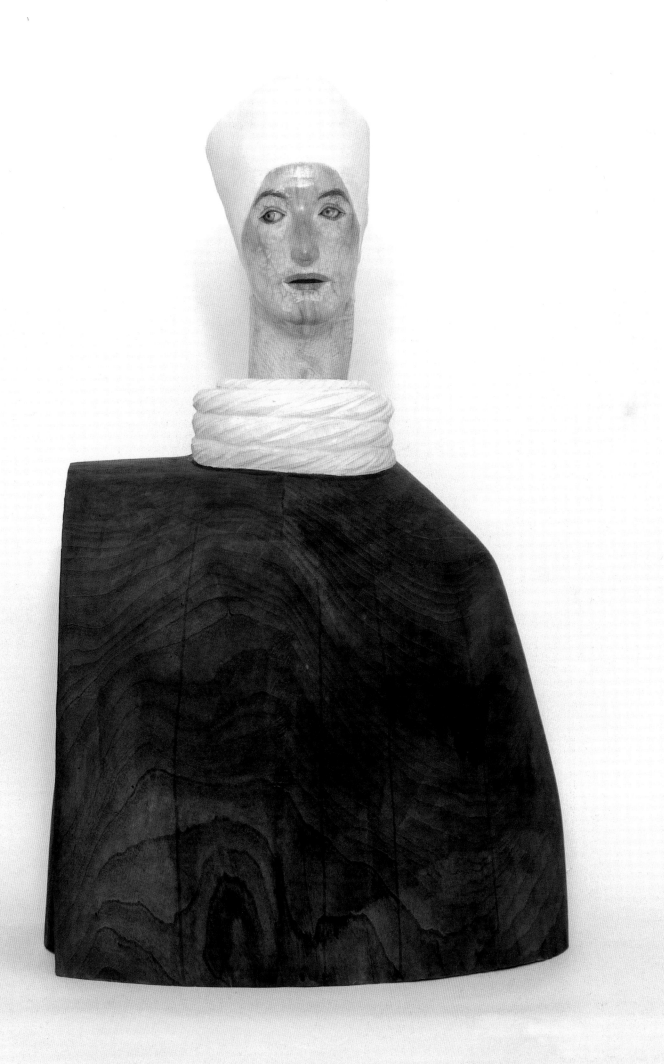

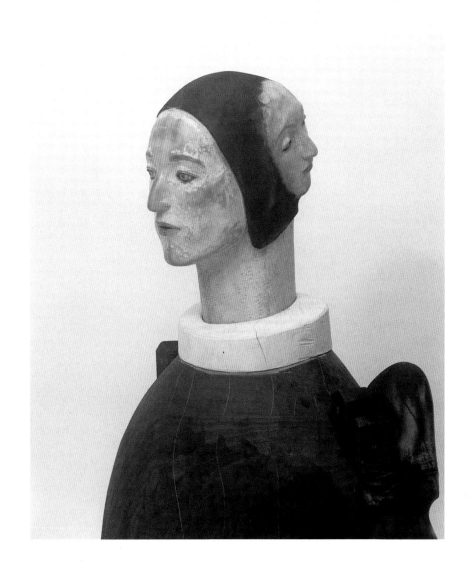

The Moon Runs, 1995

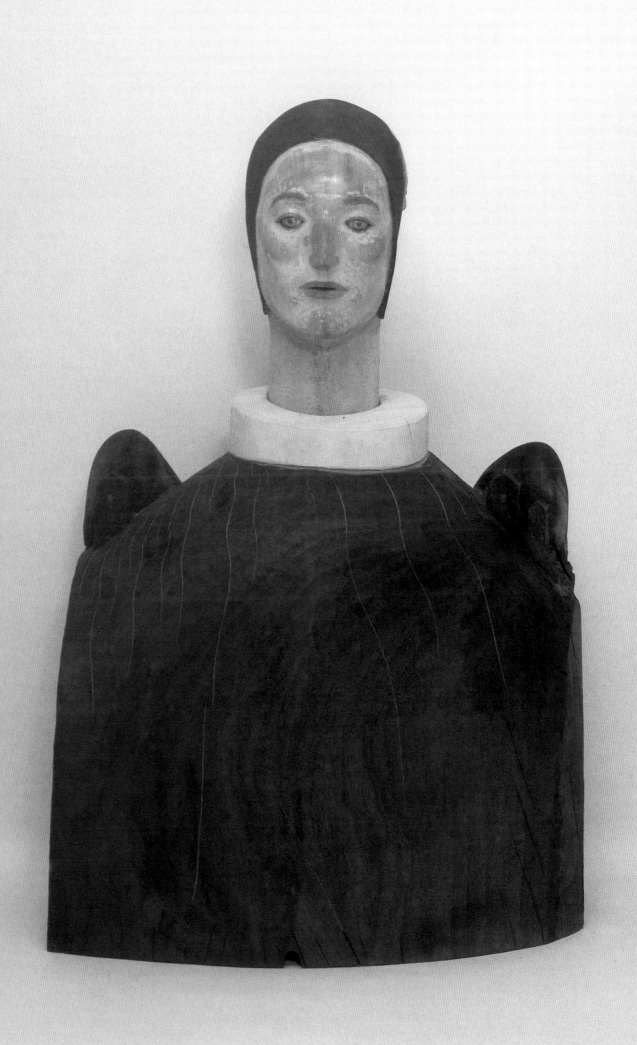

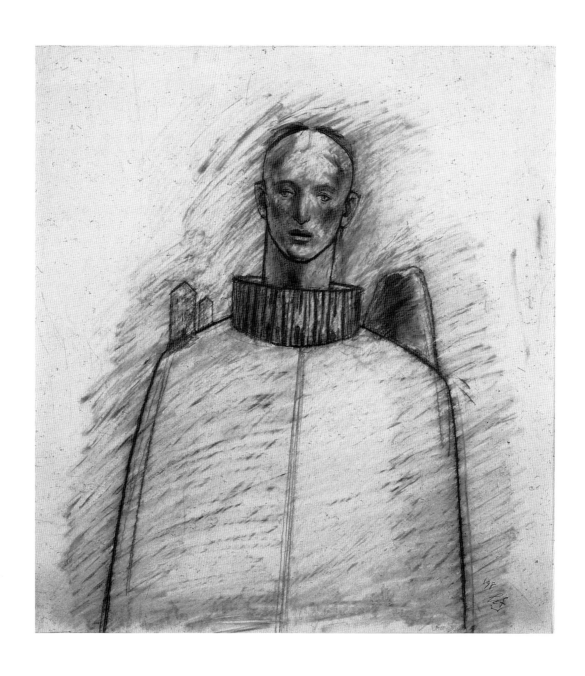

Drawing for 'Night falls over Mountain', 1998
Night falls over Mountain, 1998

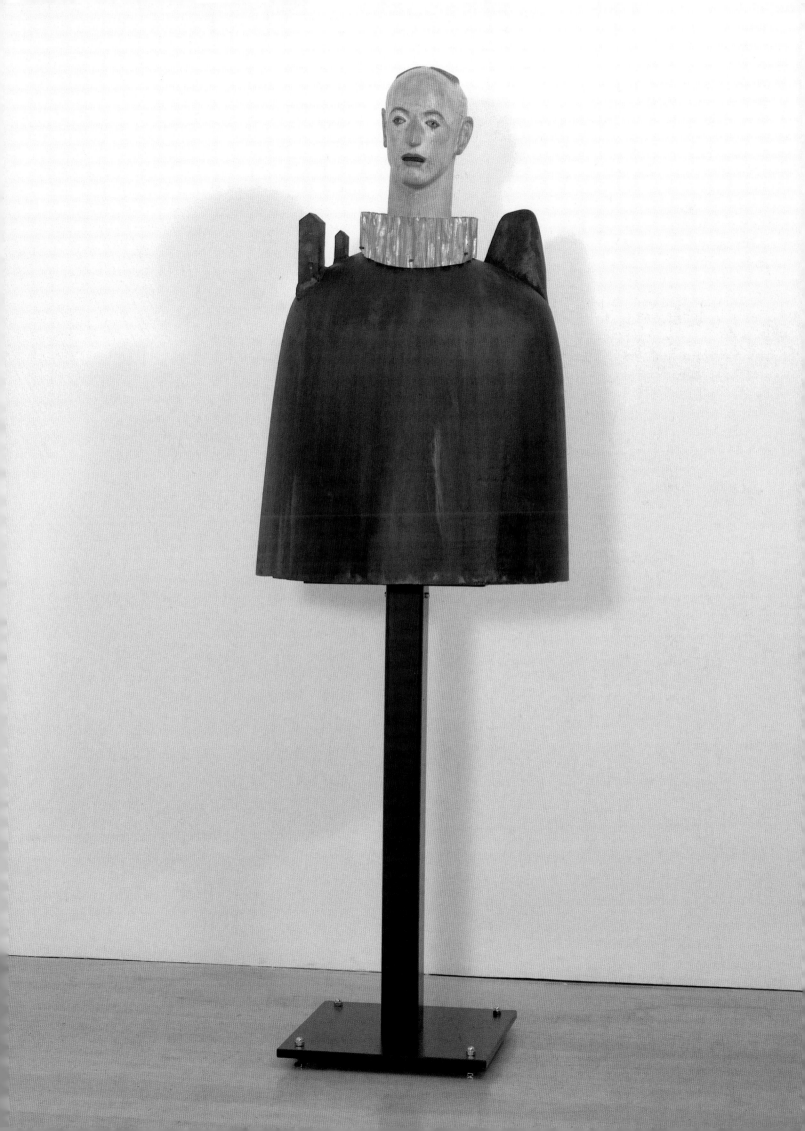

Dieter Brunner

'... not too hard and not too soft'
Camphor Wood – The Material of Funakoshi's Sculptures

I. Trees and their Myths

To understand the use of wood as a material for sculpture it is usual to start with the diverse symbolism of the tree, for it is one of the oldest archetypes of man which can be found in almost every culture. The original image of the tree, the Tree of the World with its crown that stretches into heaven and roots that reach deep into the earth, is a concept of the world that is indigenous to many peoples. The tree plays a major role in religion, art, fairy and folk tales as well as in legal and national customs.[1] Trees have been used both as meeting places for celebrations and trials but also for executions and death. According to several stories of The Creation Man is a descendant of the tree.

The tree as a sacred place is known in almost all religions and cultures: wooded glades and forest, for instance were favoured places of worship in ancient Greece as they were held to be the home of Gods and spirits. The concept of the holy tree was supported by the belief that trees are similar to human beings in that they grow, they are subjected to seasonal change, they are mortal and, like man, they possess a soul. Trees were worshipped through sacrificial offerings, wreaths and other holy presents. The blossoming, evergreen tree is regarded as a symbol of life and vitality. Its fruits are held to bestow health, youth and eternal life. In the Old Testament the Tree of Life in the story of Creation is situated right in the centre of the garden of Eden. The Tree of Knowledge, which enables us to distinguish between good and evil, also stood in paradise. Its symbolic meaning is very similar to that of the Tree of Wisdom. Traditionally trees can make prophecies, provide solace, and sometimes even the Voice of God can be heard inside them.

Several of these ideas have their equivalent in Japanese religions. The worship of nature is an important aspect of Shinto, the indigenous religion of Japan. The evergreen Sakak and Hinoki trees are held sacred in Shinto as a spirit is believed to dwell within them. The practice of Shinto includes for instance, the offering of branches of the cherry tree. In Japan, forests were originally thought to be the home of the Gods and therefore no temples were built there. However special clearings enclosed by trees later served as places of worship for Shinto services.

Buddhism adapted the cult of the tree from older religions but with one important difference: it was no longer the tree itself that was venerated as sacred but rather the deity within it. All the important events in the life of Bodhisattva Siddharta (c. 560 – 480 BC), the founder of Buddhism, took place under a tree: birth, death, first meditation and enlightenment, which he experienced under a Bodhi tree which was already worshipped by Buddhists in Buddha's lifetime.[2]

II. Funakoshi's Sculpture and the Traditional Uses of Wood in Japan and Europe

Funakoshi's use of wood is linked to a long Japanese tradition of working with this material. Both secular and sacred buildings are still predominantly made of wood. The tradition of creating sculptures out of wood also stretches back a long time especially in connection with Buddhism. Wood became the preferred material in the Heian period (8th – 12th century) when the forms and techniques typical for Japanese art of that time were developed, such as the removal of the heartwood and the assembly of carefully chosen blocks of wood.

Funakoshi was inspired by the animated sculptures of the Kamakura period (1185 – 1333). This culture pro-

duced 'realistic' portraits of either muscular warrior kings or important teachers of Zen Buddhism. These portraits with their strict observance of form were carved from pieces of wood that were joined together and used crystal eyeballs that were inserted through the back of the head – a technique that Funakoshi adapted and developed with his own sculptures.

Certainly, one of the main reasons for the predominant use of wood in Japan was the relative lack of other materials such as stone. However its availability was not the only important factor governing the choice of this particular material, but also the artist's relation to it due to its simplicity, vitality, radiance and holy aura.

Another important influence on Funakoshi's work is from western art. The use of wood in art has an equally long tradition in Europe, particularly in the regions north of the Alps which extended far into the Middle Ages. The art of wood carving reached a peak during the Gothic period and was mainly used with Madonna figures, crucifixes, triumphal arch groups and other images of worship, especially the carved altar pieces of the 14th and 15th centuries. Funakoshi's Catholicism, a religion practised by only a small minority in Japan, helped familiarise him from an early age with these Christian subject matters. He was also introduced to western art by his father, Yasutake Funakoshi, who created figurative works in bronze or marble that were influenced by European sculpture, especially by Auguste Rodin. Funakoshi holds a unique position in Japanese contemporary wood sculpture. Wood is still a much used material in Japan but particularly with the work of abstract sculptors.

After the use of wood in art had fallen into disuse, its subsequent rediscovery in Europe was at the beginning of the 20th century by artists involved with Expressionism and Cubism due to a re-evaluation of non-European, especially African sculpture. Henry Moore played an important role in the development of European wood sculpture for he concentrated the properties inherent in the material itself. Since the beginning of the 1980s wood has again become a favourite material of contemporary sculptors. This renaissance began with Georg Baselitz's impressive wood sculpture 'carved' with an axe that was roughly painted and was exhibited at the 1980 Venice Biennale. Since then German sculptors in particular have turned to the use of wood in their sculpture such as Karl Manfred Rennertz, Rudolf Wachter and Stefan Balkenhol, to name a few, and in whose work the chain saw has long replaced the chisel as the most important tool. In other European countries there are isolated examples of sculptors working in wood, for instance, David Nash in England and Giuseppe Penone in Italy.

III. Truth to Material – A 20th Century Dogma

For much of the 20th century the form chosen by a sculptor was mainly influenced by the subject matter and the material used played only a subordinate role in the creative process. For a long time the materials employed with Gothic sculpture were disguised heavily, to such an extent that they became invisible. Carving was, so to speak, only the first phase – the foundation – of the work of art, so for instance a Gothic altar piece was only completed after colouring was applied onto the surface that was thus not only painted but further refined.[3] However since the end of the 15th century a few sculptors working with wood increasingly appreciated the beauty of this material in its own right. The deliberate rejection of colouring combined with an increased attention focused on the wood material itself began with such artists as Tilman Riemenschneider and Veit Stoß.

At the beginning of the 20th century, the marks left by the use of the chisel and other tools played an important part in wood sculpture. These marks emphasised the importance of the material itself for the creative process and so increased the artistic importance of wood. In the 20th century the concept of 'truth to material' was explored by Henry Moore, particularly in his early period, for as he noted: 'Every material has its own individual qualities. It is only when the sculptor works direct, when there is an active relationship with his material, that the material can take its part in the shaping of an idea. Stone, for example, is hard and concentrated and should not be falsified to look like soft flesh ...'[4]

After Henry Moore the dominant aesthetic for sculpture became 'Form follows material'[5] especially after the

Second World War. Henry Moore also began to distance himself from this idea: 'I still think it's tremendously important but I used to exaggerate the importance.'[6] The tradition of taking into account the properties inherent in the material and their display is still evident in contemporary wood sculpture. Sculptors often adapt their designs to the shape of the wood and its structure as the material provides an important starting point for the sculptural concept and therefore determines the working process.

Funakoshi has certainly been influenced by these 20th century European ideas but has decided to emphasise the idea behind the figurative sculpture he creates. He usually formulates his ideas about the shape of the bust, its proportions and formal outlines in preparatory sketches. Funakoshi always ensures that the wood remains visible underneath the colouring of the bust so that the strong grain of the wood appears through the delicate paint surface, but at the same time he hardly applies any paint to the face. The artist also includes the various tool marks which are a characteristic feature of wood carving starting from the rough blocking out to the fine sanding and polishing. He also pays careful attention to the processes which will affect the wood after the completion of the work. In particular he sometimes uses devices to try to prevent the formation of cracks in the body section. Funakoshi clearly demonstrates the importance of wood for his creative process in this statement: 'The material I use (...) is important, it influences the result. I am seeking the perfect tension or moment between the material and the image.'[7]

IV. Funakoshi's Treatment of Wood

Funakoshi first used camphor wood in 1977 on the recommendation of one of his teachers at his University after he had received a commission to create a Madonna and Child figure for the monastery of the Trappist order in Hakodate. He has been using this material ever since.

The camphor tree is a laurel tree which is found widely in China and Japan and can reach up to 40 m in height. Its leaves are used for medicinal purposes both as a stimulant for the heart and to aid breathing. Funakoshi later explained that 'Camphor wood is neither too hard nor too soft. It smells nice and its colour is just like the skin of Japanese people, not too white and not too brown. When I sat down and worked for months and months on the Madonna figure I knew that this was my wood.'[8] For this commission Funakoshi studied Christian imagery and rediscovered Tilman Riemenschneider whose motifs he had known since childhood. Riemenschneider's treatment of wood in particular fascinated Funakoshi. It was at the end of the 15th century that Riemenschneider abandoned the colouring that was customarily applied to wood sculptures with the exception of a few details and so demonstrated that he valued the varnished and finely worked surface for its own sake.

In the sculpture 'Portrait of my Wife' of 1981, Funakoshi found for the first time a form and expression that corresponded to his main motif: 'man who represents the whole of humanity within himself but nevertheless remains an individual'[9]. In this sculpture the elongated bust shape and the clear almost unapproachable facial expression appear for the first time. The characteristic features of the sculptures that followed were: inserted marble eyeballs, poetic titles, polychrome colouring with contemporary clothing and, from the beginning of the 1990s, monk-like cloaks and skull caps which are reminiscent of the headgear worn during the Italian Renaissance.

Funakoshi's wood sculptures are created in several stages.[10] After his preliminary drawings, the body section and the head of the sculpture are carved separately. Funakoshi first works on the head with a chain saw. He then refines the resulting squared shape with a rough carving knife repeatedly referring to the drawn guidelines he makes on the wood. The eyes remain hidden in the wood for a long time and are only marked by dark paint. They are, so to speak, fixed points for further action. Through the application of whiting followed by sanding and polishing, Funakoshi achieves a painted surface which closely resembles the colour of skin. Finally the head is cut open and hollowed out from the back before the marble eyeballs are inserted and the holes are sealed. For the eyes Funakoshi employs a similar albeit modified technique to that used by the Japanese sculptors

during the Kamakura period. Instead of crystal eyeballs he uses marble spheres which he then paints and onto which he applies red cotton threads before they are varnished to give them a shiny surface.

The body section of the bust is created in a similar way. It is carved in a relatively rough manner and then most sculptures are delicately painted. Funakoshi only uses a small range of colours. Compared to the head, the body is hollowed out relatively coarsely and because its walls are thicker it is more prone to develop small cracks during the drying out of the wood.

The head and the body sections are assembled only after the separate parts are completed. Funakoshi does not hide the fact the sculpture consists of two parts: the joints are not disguised by planing them down and sometimes the head part does not fit tightly. After the sculpture is assembled it is mounted onto a steel base composed of a thin vertical rod with a plate on top so that the figure is roughly at eye level. Sometimes Funakoshi adds 'real' features such as spectacles to his sculptures.

V. The Hollowing Out of the Wood

Mediaeval sculptors carved the body of a figure from one thick trunk of wood after roughly working out the contours. To save time and effort, the projecting parts were made from separate pieces of wood using concealed joints. Religious sculptures were hollowed out to minimise the development of large cracks. After the block of wood had been cut in half, the heartwood was removed quickly and the walls reduced to a thickness of 2 – 8 cm so that the the piece could dry out quickly and more evenly. The resulting hole at the back of the sculpture was finally sealed with a lid.[11]

The technique of hollowing out has also been used in Japan since the 8th century with the creation of wooden figures of Buddha. The sculptures that have survived were either carved from a single block of wood or hollowed out from the back or from underneath. Following the 11th century a special technique was perfected for the fabrication of large wooden figures which were made out of individual wood blocks that had been carefully hollowed out before being assembled together. This technique was not used by western artists until the 20th century.

In principle, Funakoshi always uses the method of working from a single piece of wood. Each of the two parts of his sculptures are made from different parts of the same block which are then hollowed out. He very deliberately uses the original method of the hollowing out process, which helps the drying process of the wood but uses this in very different ways. The wooden walls of the head section are thinner and therefore largely without cracks but with the body section which is hollowed out more coarsely, the wooden walls are thicker and the development of cracks is tolerated. This working method results in a progressively more 'perfect' smooth surface beginning from the relatively roughly carved body section through to the smooth head and the shiny eyes. This striving for smoothness and perfection with the use of a second material, marble, leads the viewer towards the gaze of the eyes – in a similar way, for instance, as with the portraits of Rembrandt.

VI. Material and Illusion

Wood is a material that asserts conditions and demands that the sculptor has to enter into a dialogue with. It is not a neutral material in structure and its very specific properties are exemplified both by the uniqueness and distinctiveness of an individual piece of wood and by the contrariness and unpredictability of the grown material. So the use of wood always presents a challenge to the sculptor who has to both work with but also against it. Since wood is a living material that is part of nature is important for Funakoshi for he has written that 'when you touch wood it is warm, unlike the feel of stone or steel. Although he has not explicitly said so, wood is organic, it has come from a living thing, and indeed that process continues.'[12] Wood is alive and it continues to work, for it is natural, transitory and vulnerable.

The relationship between man and tree has frequently been pointed out so that the tree was sometimes regarded as the 'brother of man'[13]. Similarities have been drawn between the foot and the root of trees, the tree

trunk and the body, between branches and arms or fingers, as well as between the crown and head. There are also some resemblances between the structure of human skin and the bark of a tree.

Funakoshi works with these affinities: with their elongated body his sculptures retain something tree-like and similarly he almost always deliberately avoids the addition of hands or gestures. The surface and transparency of wood also suggests human skin and its grain is reminiscent of fine veins together with the cell structure of wood which is similar to the pores of human skin. Funakoshi's sculptures seem to remain trees and yet become humans at the same time. They almost stand for the common fate of man and plant.

Change and transience are expressed in wood – life and death. Funakoshi's sculptures also include both aspects of these two extremes: on the one hand facial expression and gesture and on the other restrained movement and a rigid pose. This ambiguity of time and timelessness leads Funakoshi to a strange mixture of reality and imaginary: his sculptures are near and yet far away, they are taken from life but they are nevertheless static. It is this aspect in particular which makes the sculpture so interesting in that Funakoshi refers to a frontal block-like confined archaic posture. Funakoshi's archaic figure leaves the durable stone and slips into the finite wood.

But continuity is nevertheless relevant for Funakoshi but only in the sense that he never wants to depict just a single moment: 'It ... seemed possible to convey the feeling that the figure was by my side. I would like to create human beings that continue to exist as time passes.' [14] His intention is therefore not just the single moment but rather a continuum leading to spirituality. He aims to create calm, contemplating figures: 'Individuals between spirituality and corporeality' [15]. With these figurative sculptures Funakoshi performs a very risky balancing act, as perfection and illusionism can quickly slip into banality. But by using wood Funakoshi can bring his works so close to nature that he can therefore exploit the freedom of creation. He is able to reduce their illusionistic qualities by, for instance, retaining some of the marks of his workmanship in their faces. Also he almost revokes the physical presence and lifelike quality of the figure through its motionless pose with an introspective almost unapproachable expression. The wood which is used with the addition of the marble eyes gives us a very different feeling of reality compared to wax or synthetic resin and allows a wholly different distance from its 'likeness', without loosing its affinity to nature.

Unlike Duane Hanson's sculptures, Katsura Funakoshi's figures are deliberately artificial beings. Funakoshi is interested in the polarity between the naturalness and the artificial. The artificial remains in tension with the living image but because the figure remains artificial it then becomes much more impressive and alive than the art works of the hyper-realists who rely solely on the great powers of illusion and deception.

In this way Funakoshi not only qualifies the illusionistic aspects of his work but creates ambiguous areas of tension. This contrasts with Duane Hanson whose sculptures Funakoshi saw at an exhibition in Tokyo. He found he was both impressed and disappointed at the same time and reportedly exclaimed: 'It does not move' [16].

1 In the following cf. Manfred Lurker, *Wörterbuch der Symbolik*, Stuttgart 1991, p. 80 f; Sybille Selbman, *Der Baum. Symbol und Schicksal des Menschen*, Karlsruhe 1984; Hans Gercke (ed.), *Der Baum in Mythologie, Kunstgeschichte und Gegenwartskunst*, cat. Heidelberg 1985, pp. 52 – 151

2 Cf. Hans Gercke (ed.), *Der Baum in Mythologie, Kunstgeschichte und Gegenwartskunst*, cat. Heidelberg 1985, pp. 63 – 68

3 In the 19th century these works were often stripped due to the prevailing classic aesthetics.

4 Philip James (ed.), *Henry Moore on Sculpture*, New York 1991, p. 72

5 Cf. Anna Bechinie, *Katsura Funakoshi. Skulptur zwischen zwei Kulturen*, Magisterarbeit, Bonn 1998, p. 66

6 Philip James (ed.), op. cit., p. 115

7 Funakoshi quoted in an interview in August 1990 with Constance Lewallen, Crown Point Press, San Francisco, in *View*, vol. VII, No. 3, Fall 1990

8 Martin Tschechne, 'Katsura Funakoshi. Blicke in die Unendlichkeit der Seele', in *Art. Das Kunstmagazin*, No. 3, March 1996, p. 24

9 Ibid.

10 Cf. Anna Bechinie, op. cit., pp. 68–70

11 Cf. Hans Westhoff, 'Vom Baumstamm zum Bildwerk. Skulpturenschnitzerei in Ulm um 1500', in *Meisterwerke massenhaft*, cat. Stuttgart 1993, pp. 253 – 256

12 Cf. Marina Vaizey, 'Number of Words Arrived', in *Katsura Funakoshi. Sculpture*, cat. Annely Juda Fine Art, London 1991

13 Hans Gercke, 'Brücke zwischen Mythos und Aktualität. Der Baum in der Gegenwartskunst', in Hans Gercke (ed.), op.cit., p. 295

14 Cf. Marina Vaizey, 'Number of Words Arrived', in *Katsura Funakoshi. Sculpture*, op. cit.

15 Cf. 'Funakoshi', in *Today Artists V–'93*, The Museum of Modern Art, Kamakura, pp. L – L I

16 Martin Tschechne, op. cit., p. 25

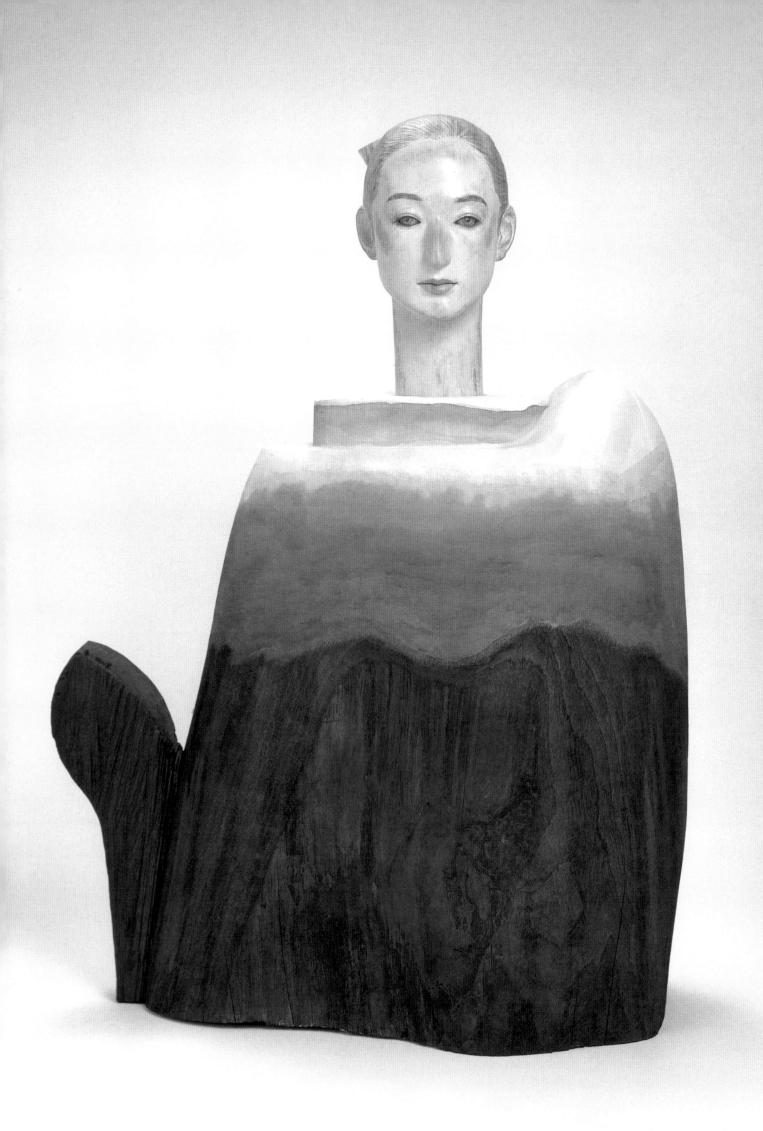

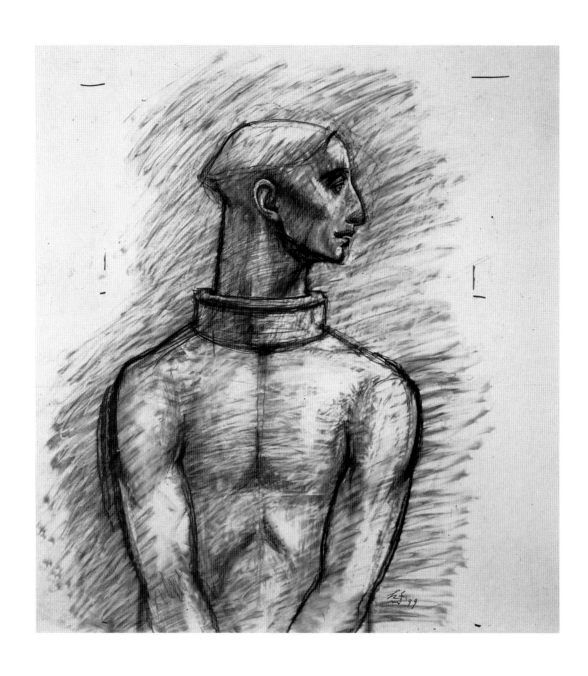

Drawing for 'Panther Lurking in the Library', 1999
Panther Lurking in the Library, 1999

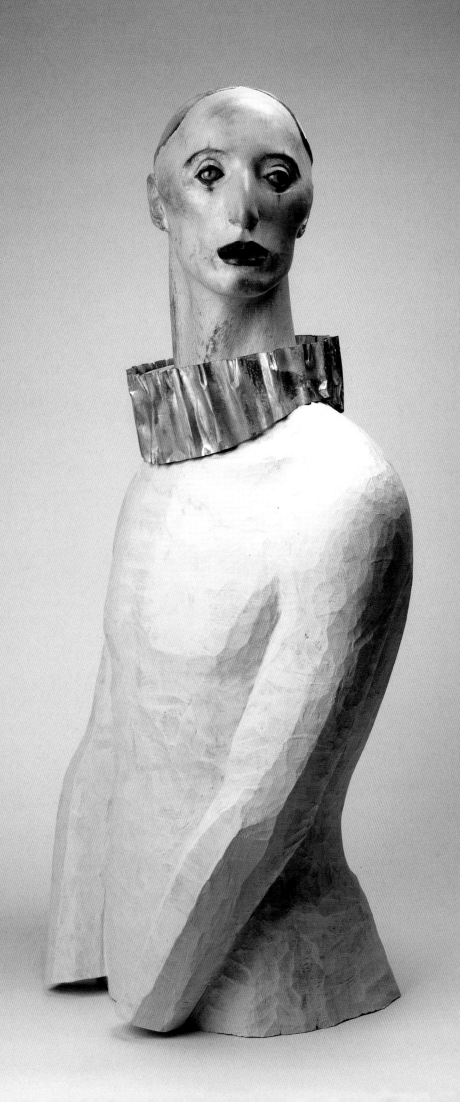

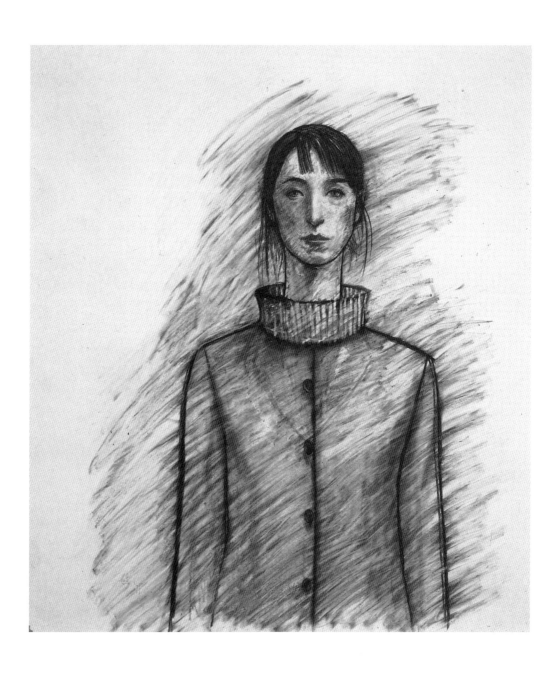

Drawing for 'A Map of the Time', 1999
A Map of the Time, 1999

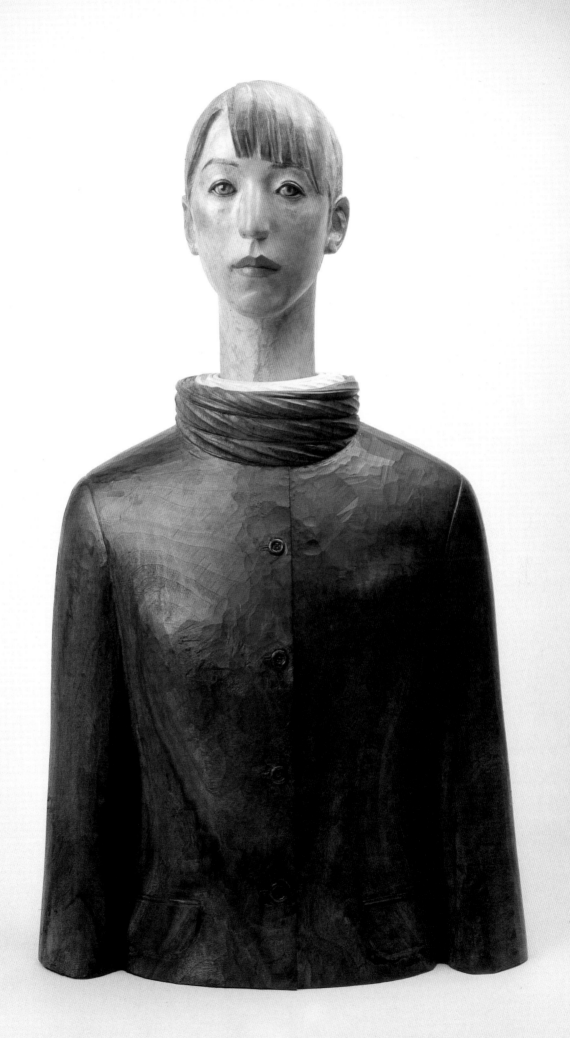

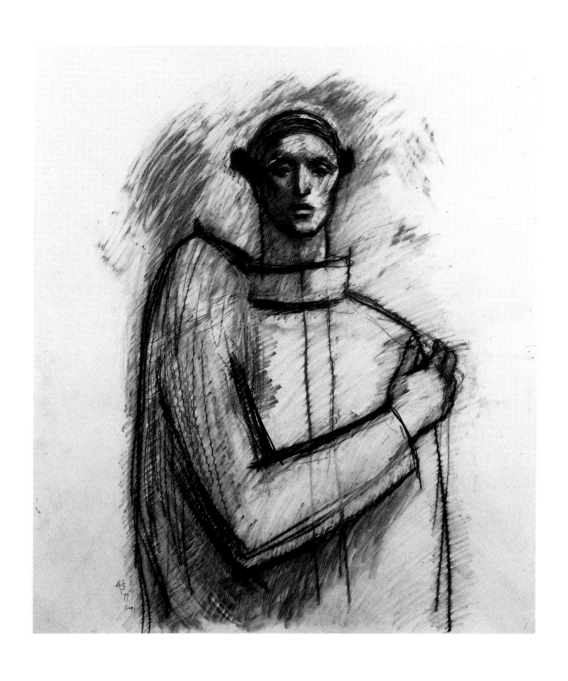

Drawing 9925, 1999
A Herald of Winter, 1999

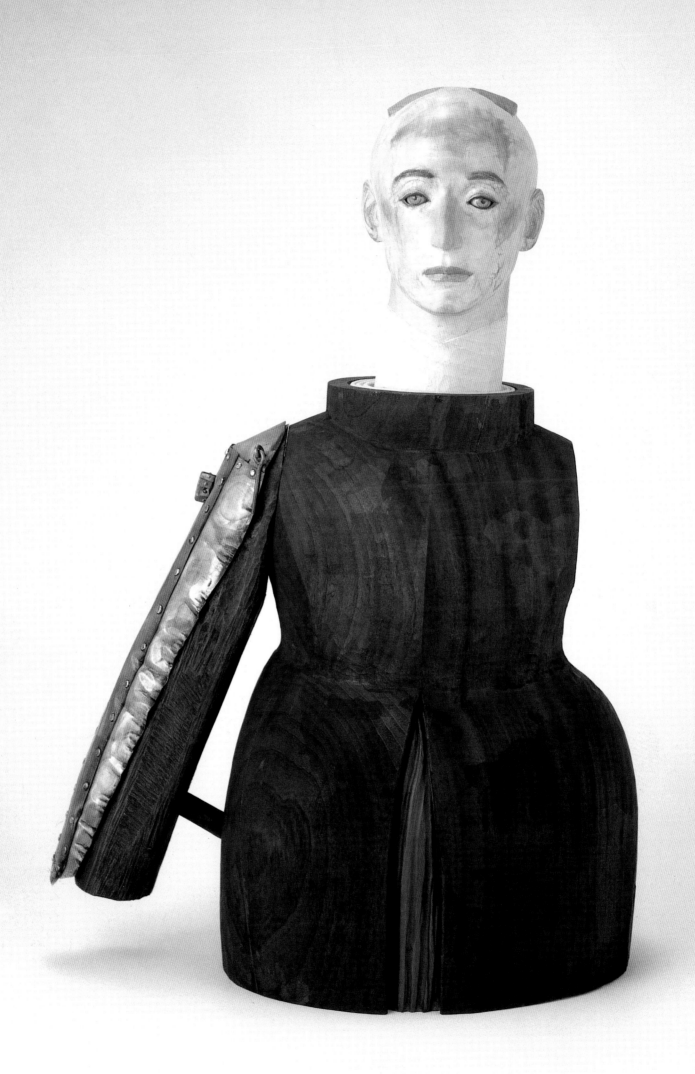

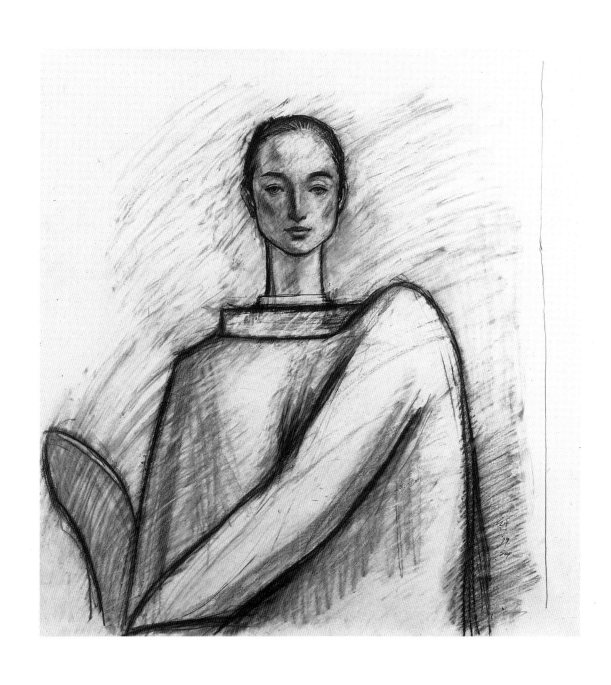

Drawing 9923, 1999
Blue Arm, 1999 (work in progress)

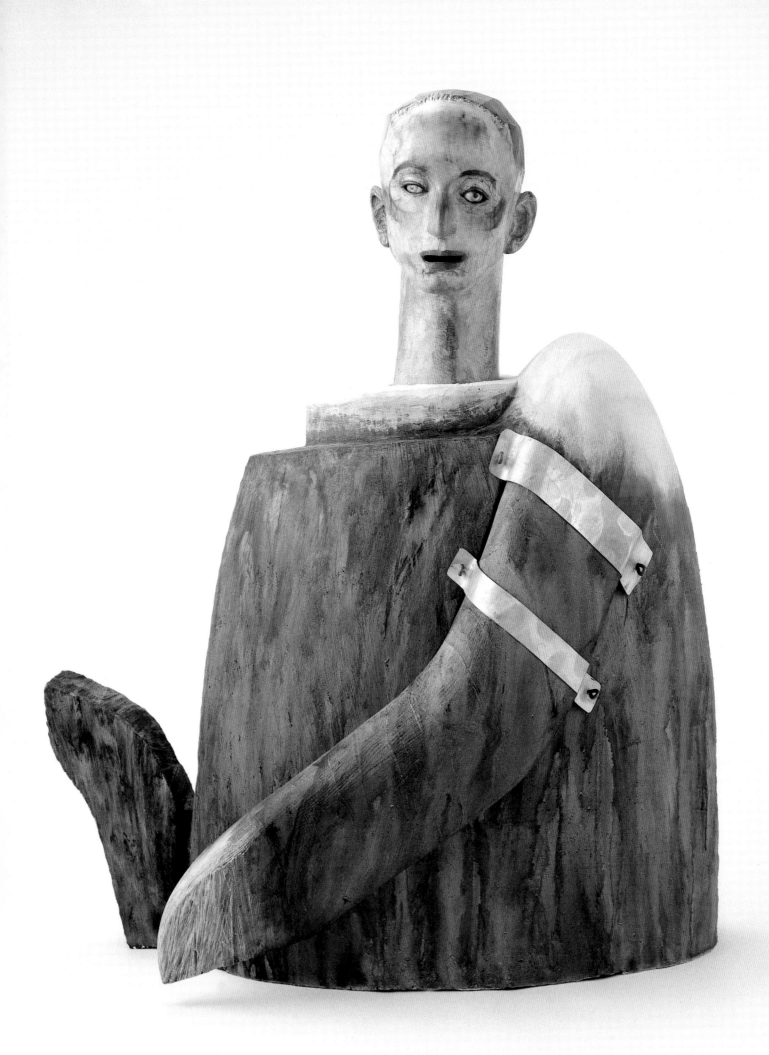

Ferdinand Ullrich

Wirklichkeit und Wirksamkeit im Werk von Katsura Funakoshi

Daß am Ende des Jahrhunderts das Menschenbild im Werk von Katsura Funakoshi errettet scheint, ist ein bemerkenswertes Phänomen. Noch zu Mitte des Jahrhunderts wurde sein Verlust beklagt als ein Zeichen des kulturellen Verfalls und des Niedergangs christlich-abendländischer Werte. Die Entwicklung der internationalen abstrakten Kunst der 50er Jahre ging jedoch über dieserart konservativen Kulturpessimismus hinweg.

Daß sich die so angegriffenen, abstrakten Künstler – z. B. die Künstlergruppe Zen 49, 1949 in München gegründet – ausdrücklich auf ostasiatische Philosophie bezogen, macht andererseits deutlich, daß sie die Prämisse der Kritik durchaus teilten: Das einzelne Werk steht für ein übergeordnetes Ganzes, eine geistige Mitte. So gibt es in jedem gültigen Kunstwerk zugleich ein Nahes und ein Fernes. Die Künstler des deutschen Informel wie des amerikanischen Abstrakten Expressionismus sahen allerdings das Nahe und Ferne, das Werk und seine Idee, in der Ungegenständlichkeit stärker verbunden als ein das wiedererkennende Sehen provozierendes, mimetisches Bildwerk.

Die grundsätzliche Frage gilt so auch für ein Werk, wie das Funakoshis, das die außerbildliche Referenz zu mehr als einem bloßen Malanlaß macht: Was weist über das einzelne Werk hinaus, welche sinnlich wahrnehmbaren Momente haben das Potential, jene übergreifende Idee zumindest erahnbar zu machen?

Dem Werk Funakoshis kommt eine Eigenschaft in besonderer Weise zu, die Walter Benjamin als Aura bezeichnete und deren Verlust er für das Kunstwerk im Zeitalter seiner technischen Reproduzierbarkeit – diesmal aus einer progressiv kulturkritischen Position – konstatierte. Im Blick hatte er die Fotografie, die zum einen eine nie dagewesene Perfektion in der Wiedergabe der optischen Wirklichkeit erreichte, zum anderen potentiell unendlich reproduzierbar war und so den Verlust der Einzigartigkeit hinnehmen mußte. Aura beschreibt Walter Benjamin „als einmalige Erscheinung einer Ferne, so nah sie sein mag". Dies ist die Wirkung des klassischen Kunstwerks, das durch die noch so perfekte Reproduktion des Originals nicht einholbar ist, während sich die Frage nach dem Original bei der Fotografie gar nicht erst stellt.

Die virtuelle Bilderflut am Ende des 20. Jahrhunderts vermittelt die Ferne als unmittelbare Nähe. Die Nähe der virtuellen Bilder ist aber nur unter der Bedingung der Materielosigkeit, also unter Verzicht auf das Hier und Jetzt und schließlich die Aura, möglich.

Das Auratische ist schon von seiner Definition her das Gegenteil einer simplen realistischen Auffassung. Aura bedeutet Mythos, Geheimnis, Vielschichtigkeit und Unauflöslichkeit in diskursive Begrifflichkeit.

Angesichts der nun tatsächlich eingetretenen unendlichen Reproduzierbarkeit durch die materielosen Bilder behauptet Funakoshi die Singularität des einzelnen, von Künstlerhand gemachten Werkes. Ist die virtuelle Welt nur noch entrückt, so leistet die klassische Bildhauerei Funakoshis beides zugleich: Nähe im Modus ihrer Materialität und Ferne im Modus ihrer Erscheinung als Bild.

Die besondere Betonung der Augen seiner Skulpturen macht dies im Detail unmittelbar sinnfällig. Sie blicken durch ihre deutliche Parallelstellung in die unendliche Ferne. Sie demonstrieren damit eine Geistesabwesenheit, die eigentlich eine Geistesanwesenheit ist, weil die konkrete Skulptur das Medium dieser – durchaus romantischen – Erfahrung ist. Der Blick ins Unendliche ist zugleich der Blick in das Innerste des eigenen Selbst.

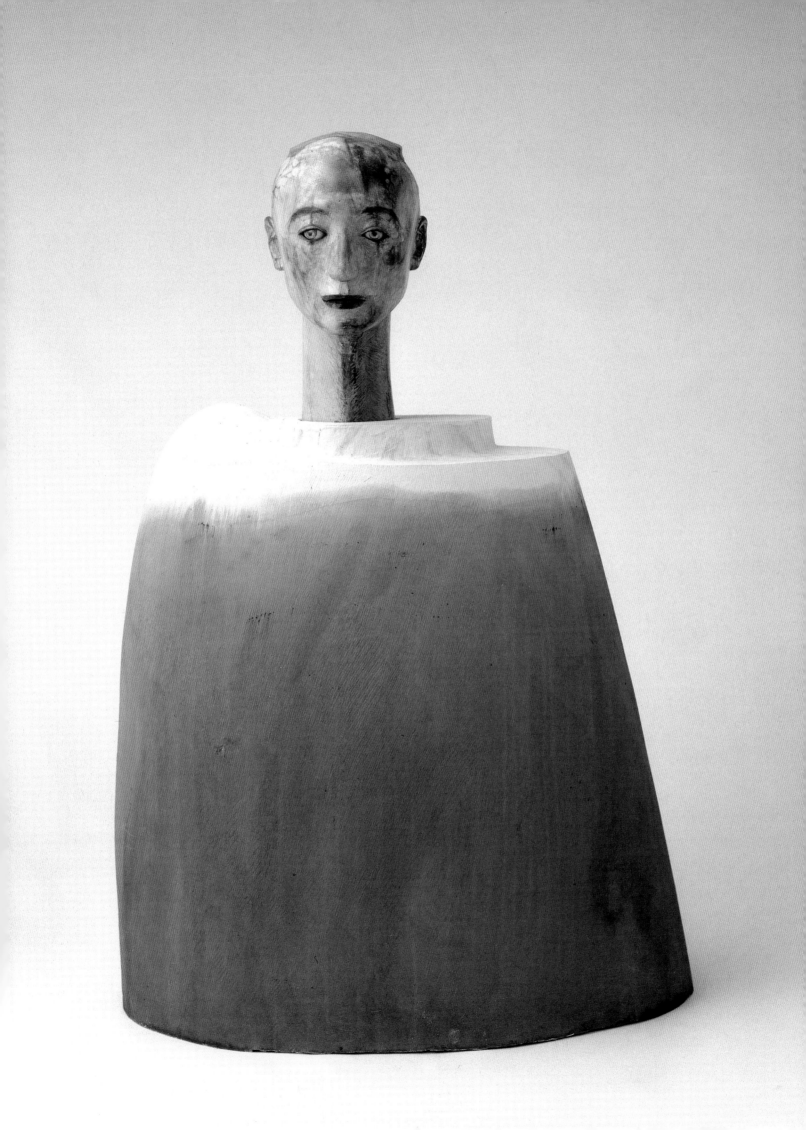

Die Welt so darzustellen, wie sie ist oder wie sie wäre, selbst wenn das Individuum, das diese Wirklichkeit wahrnimmt, nicht existierte – das ist das Credo des Realismus im 19. Jahrhundert.

Aber schon Courbet verstand Realismus keineswegs als die bloße Wiedergabe der äußeren Wirklichkeit, sondern als den Versuch, dem Beweggrund dieser optischen Wirklichkeit Ausdruck zu geben, indem er „realistisches" Material, wie Sand, seinen Farben untermischte.

„Ding an sich" (Kant) oder „Wille" (Schopenhauer) nannten die Philosophen des 19. Jahrhunderts diese geistige, metaphysische Wirkkraft, die sie als eigentliche „Wirklichkeit" verstanden, das Motiv des Welthandelns.

Dagegen setzt das 20. Jahrhundert unter dem Eindruck der mechanischen Bildtechniken auf die „Errettung der äußeren Wirklichkeit", auf das Feld „vor den letzten Dingen" (S. Kracauer) als einem notwendigen Unternehmen, die Schönheiten der Welt im Hier und Jetzt wahrzunehmen und nicht allein als eine transzendente Größe.

Katsura Funakoshis Thema sind diese „letzten Dinge". Aber er führt diese „innere Wirklichkeit" im Modus ihrer optischen Erscheinung vor Augen. Ihre Schönheit ist der angemessene Ausdruck, die Repräsentanz des geistigen Urgrundes in der Welt der Vorstellung und eine Brücke zwischen Transzendenz und Sichtbarkeit.

In der Wertschätzung der künstlerischen Gattungen hatte die Skulptur eine herausragende Stellung. Dem Idealismus der Malerei setzte sie die Wirklichkeit des plastischen Körpers gegenüber.

Auguste Rodin hat diesen Realismus gesteigert, indem er die Skulptur noch näher an den Betrachter heranholte, die ästhetische Grenze des Sockels aufhob. Er hat sie in gewisser Weise entzaubert, ihre Aura empfindlich verletzt.

Hier geht Funakoshi eher einen Schritt zurück, indem er die Büstenform bevorzugt, die den Sockel notwendig macht. Diese Form schafft Distanz gegenüber dem Betrachter, der sich nun mit der ästhetischen Grenze eines notwendigen Sockels konfrontiert sieht. Das Werk ist nicht mehr das gleichberechtigte Gegenüber, sondern ein Artefakt mit eigenem Wirkungsraum, in den sich der Betrachter erst hineinbegeben muß. Dem Mythos wird erneut ein Entfaltungsraum gegeben. Trotz der Lebensgröße der Büsten oder Halbfiguren wird so die Nähe zwischen Betrachter und Skulptur durch eine bewußt gesetzte Grenze partiell aufgehoben.

Bekleidung und farbige Fassung der Figuren dagegen bedeuten einen höheren Grad an Wirklichkeitsnähe. Dieser Illusionismus überdeckt die materielle, man könnte auch sagen, „realistische" Substanz der Skulptur. So steht nicht das Gemachtsein im Vordergrund, sondern die Gesamtheit der körperlichen Erscheinung. Diese wiederum ist nicht als mimetisches Abbild kommensurabel – das verhindert unter anderem die Büstenform –, sondern es ist das durchaus brüchige, weil unvollkommene Äquivalent der körperlichen Erscheinung des leibhaftigen Menschen.

Der Verzicht auf jegliche, gegenständliche Spontaneität hebt das Werk über das bloß Einzelne und Zufällige hinaus. Expressionslose, konzentrierte Körperlichkeit als Errettung des spirituellen Zentrums erscheint geradezu als eine Notwendigkeit in der aufgeregten Jahrhundert-Endstimmung.

Ein Gradmesser für den äußeren Realismus kann die Behandlung des künstlerischen Materials sein. Dieses und seine künstlerisch-handwerkliche Behandlung zu offenbaren oder beides vergessen zu machen, sind sehr unterschiedliche Auffassungen von Wirklichkeit und ihrer Repräsentanz im Kunstwerk.

In dem Maße, wie die Skulpturen Funakoshis in der Welt sind und gleichzeitig über sie hinaus weisen, findet sich der materielle Bestand im Zwischenreich von Dasein und bloßer Erscheinung, von bearbeitetem Material und Bild.

So sehr hohe Handwerklichkeit eine der Grundbedingungen seiner Kunst ist, so wird dieser Aspekt aber keineswegs überbetont. Perfekte Handwerklichkeit ist immer in der Gefahr expressionsloser Glätte; an der makellosen Oberfläche könnte sozusagen jeder Versuch des geistigen Eindringens oder geistiger Ausstrahlung abprallen. Die physiognomisch-körperliche Emotionslosigkeit könnte so in das nur Artifizielle führen, in die Blutleere bloßer Künstlichkeit.

Funakoshi läßt dagegen sowohl die materielle Basis wie auch das Handwerkliche – wenn auch vermindert – durchscheinen. Seine Figuren stehen zwischen Gemachtsein und Gewordensein, zwischen Subjektivität und Objektivität.

Auch im engeren Bereich der figürlichen Plastik nimmt Funakoshi eine exponierte Mittelstellung ein: weder der Realismus der Täuschung (Hanson) – ein eigentlicher Naturalismus – noch der Realismus, der im Figürlichen die materielle Grundlage von Skulptur demonstriert (Balkenhol). Weder werden der Enstehensprozeß und die Materialität überhöht noch deren absolute Negation durch Auslöschung aller Arbeitsspuren und jeglicher Handschriftlichkeit.

Auch bei den Zeichnungen finden wir die Gratwanderung zwischen Gemacht- und Gewordensein, zwischen der Illusion des Bildes und der Wirklichkeit des Stoffes. So unverkennbar die Referenz auf die außerbildliche Wirklichkeit ist, so deutlich wird gleichzeitig die Unmittelbarkeit der Zeichnung. Die Strichführung bleibt ein wesentliches Element der direkten, gegenstandslosen Seherfahrung. Dies wird noch unterstützt durch die relative Expressionslosigkeit der Physiognomie.

Bemerkenswert ist der Verzicht auf eine plastische Durchformung, die hinter reine Flächengestaltung zurücktritt. Auch dies bedeutet einen klaren Verzicht auf Überdeutlichkeit und Realismus. Unterstützt wird dies durch die überwiegend einfachen Frontal- oder Profilansichten. Die Beziehung zu den Skulpturen ist offensichtlich. Sie sind vom gleichen Bildverständnis geprägt, zugleich selbständige Werke, die ohne Kenntnis der Skulpturen gültig sind und doch abhängig von diesen. Nicht die formale Auffassung ist die gleiche, sondern die geistige.

Unnahbarkeit des psychischen Ausdrucks und Nähe des materiellen Bestands sind die Pole dieser Kunst. Auch die gelegentliche farbige Behandlung der gezeichneten Porträts bedeutet eher einen zusätzlichen Verfremdungseffekt, wie neuerdings auch die Hinzufügung von Metall zu den Skulpturen. Dies sind formale und damit geistige Maßnahmen, die von einem oberflächlichen Realismus wegführen.

Im Modus einer realistischen Kunst zwischen Präsenz und Transzendenz, zwischen Wirklichkeit und Künstlichkeit zu vermitteln und das eine im anderen zu bewahren, macht die Bedeutung des Werks von Katsura Funakoshi am Ende des Jahrhunderts aus. Seine Kunst ist – auch wenn sie mit dem natürlichen Material Holz umgeht – gegen die Natur gerichtet. Es geht im engeren nicht darum, die Wirkkräfte der Natur etwa durch die besondere Betonung der Holzstruktur zu versinnbildlichen oder ihren unmittelbaren Selbstausdruck zu ermöglichen.

Die Schönheit der Werke von Funakoshi ist eine hergestellte, formale, also künstlerische Schönheit, die als äußere eine innere Schönheit offenbart. Anmut und Würde der Figuren sind damit mehr als ein bloßer Reflex der optisch wahrnehmbaren Welt. Es gelingt Funakoshi Erstaunliches: Das, was man der Romantik und dann erst wieder der ungegenständlichen (amerikanischen) Kunst des 20. Jahrhunderts zugestanden hat, die Evozierung des Erhabenen, gelingt Funakoshi im Modus der Figürlichkeit ohne jedes falsche Pathos. Die Ambivalenz von Zeitlichkeit und Überzeitlichkeit, von Gegenwärtigkeit und Ewigkeit, von Einzelnem und Allgemeinem setzt diese Wirklichkeit, man könnte auch sagen, Wahrheit ins Werk.

Ferdinand Ullrich

Reality and its Effect – The Work of Katsura Funakoshi

It is remarkable that Katsura Funakoshi seems to have saved the image of man at the end of this century. Only 50 years ago its loss was lamented as a sign of cultural decay with the decline of western Christian values. However, this conservative cultural pessimism was transcended with the development of international abstract art in the 1950s.

The fact that abstract artists who often were attacked in this way explicitly referred to Far Eastern philosophies such as the artists' group Zen 49, founded in Munich in 1949, demonstrates they shared the premise of these critics, namely that an individual art work can represent a higher concept, its spiritual centre. Each work of art of this kind thus includes at the same time something close and something distant. However the artists of the German Informel as well as the American Abstract Expressionists believed that closeness and distance, or the work and its concept, were expressed more successfully with abstract art than with figurative images that rely on the process of recognition. Therefore the fundamental question of what can transcend the individual art work and which object of perception has the potential to at least allude to a higher concept, also applies to a work such as Funakoshi's where extra-pictorial references become more than just a pretext for its creation.

Funakoshi's works are distinguished by the quality that Walter Benjamin called 'aura'. With his critical view of cultural development he believed that the aura of a work of art had been lost in this age of mechanical reproduction. This was, according to Benjamin, clearly demonstrated with the development of photography which had reached a degree of perfection with the representation of physical reality that had not been possible to achieve before. But it also opened up the possibility of an infinite number of reproductions which consequently lost the property of uniqueness associated with art. Benjamin described aura as 'the unique phenomenon of a distance, however close it may be'. This describes the impact of classical art which cannot be approximated by even the most faithful reproduction of the original, whereas with photography the very question of the original does not even arise.

The profusion of virtual images at the end of the 20th century conveys remoteness simultaneously with closeness. However, the apparent closeness of virtual images is only made possible by their very immateriality which in turn necessitates the renunciation of the here and now and, finally their aura. The aura is by definition the opposite of a simple realistic view. It means the mystical, almost secret and multi-layered atmosphere which cannot be reduced to any narrow terminology.

Now that virtual images have theoretically made infinite reproduction possible, Funakoshi in contrast preserves the uniqueness of the individual work that is crafted by the artist's own hands. Whilst the virtual world is remote, Funakoshi's sculptures are able to achieve both at the same time: closeness in their materiality and remoteness by means of their manifestation as image. This is evident with the special role that Funakoshi places with the eyes of his sculptures. Because the eyes are looking straight ahead their gaze leads into the far distance. They thus demonstrate a remoteness which seems absentminded only because it is the sculpture itself through which this almost romantic experience is mediated. The gaze into infinity is at the same time the gaze into the core of one's own self.

It was the aim of 19th century realism to depict the world as it is or as it would remain even if there existed no individual to perceive this reality. However, already Courbet treated realism not merely as the representation of physical reality but as an attempt to express the force at the heart of this optical reality which he tried to achieve by adding 'realistic' materials such as sand to his paints.

This spiritual, metaphysical force for the philosophers of the 19th century constituted an actual reality and the force behind the development of the world and they referred to it as 'das Ding an sich' ('the thing-in-itself', Kant) or 'Wille' ('will', Schopenhauer).

However, aspirations to save physical reality in the 20th century are placed on the 'field before the last things' (S. Kracauer) and this salvation is regarded as necessary to perceive the beauty of the world of the here and now not only in the transcendent realm. Katsura Funakoshi's subject matters are these 'things'. But he presents this inner reality in the guise of its optical appearance. The beauty of his sculptures lie with their restrained expression and their ability to represent the spiritual foundation of the world of imagination and thus build a bridge between transcendence and visibility.

Sculpture has always held a distinguished position in the hierarchy of artistic genres as it confronted the idealism of painting with the physical reality of the three-dimensional. Auguste Rodin enhanced this realism by bringing the sculpture closer to the viewer by removing the aesthetic barrier of the pedestal. In a certain sense he deprived the sculpture of its mystique and thereby harmed its aura.

Funakoshi takes a step back from this development by utilising a particular shape of the bust which necessitates a pedestal. This form establishes a distance between the sculpture and the viewer who is confronted with the aesthetic barrier of its supporting pedestal. The work is therefore no longer in the same space of the viewer but becomes an artifact within its own realm into which the viewer has first to gain entrance. The myth is given its own space in which to unfold. Despite the fact that the busts or half-figures are life-size, their contact with the beholder is partially prevented by the conscious imposition of the barrier of the pedestal.

However, the dress and colouring of the figures enhance their degree of realism. This illusion disguises the material or one could even say the real substance of the sculptures. The fact that these sculptures have been created is subordinate to the completeness of their physical appearance. The use of the bust shape is one factor that prevents the perception of Funakoshi's sculptures as 'likeness'. In this sense they are incomplete and are thus only a fragile equivalent to the physical appearance of the human being.

The denial of any spontaneity in his representation raises the work above the merely accidental. His expressionless meditative figures serve as a salvation of our spiritual centre and almost seem to be a necessity in the excited mood of our time at the end of the millennium.

How an artist treats his materials can be used as a means of measuring the degree of realism of an art work. To expose the material by leaving marks of the tools used, or to conceal them, constitute two very different concepts of reality and its representation in the work of art. Funakoshi's works are part of the world and yet lead us beyond it, they oscillate between actual presence and mere appearance, between carved material and image. Funakoshi's skilled craftsmanship is fundamental for his art but it is not overwhelming. Perfect craftsmanship always brings with it the danger of slipping into a slickness that lacks expression; a perfect surface could, so to speak, prevent any possibility of a spiritual engagement or response to the spiritual aura. The lack of emotion shown in the face and body of the sculptures could thus easily lead to an unnatural blandness.

However, Funakoshi allows the basic wood material and his workmanship to shine through, if only to a small degree. His figures stand between being made and having emerged - between subjectivity and objectivity. He occupies a distinguished position in the centre of contemporary figurative sculpture for his sculptures display neither the illusion (in fact naturalism) of deception like Hanson, nor the realism which emphasises the material itself as in the figurative sculpture of Balkenhol. On the one hand neither the tool marks nor the wood itself have a special prominence yet on the other hand they are not completely hidden.

The drawings also oscillate in the same way between the being made and having emerged – between the illusion of the image and the reality of the subject matter. The directness of the drawings is kept despite the fact that their reference to the physical world cannot be ignored. The lines drawn by the artist remain essential elements in its perception and do not merge into the subject he has drawn. This aspect is further supported by the relative lack of expression in the faces.

It is remarkable that Funakoshi avoids a three-dimensional treatment and keeps the two-dimensionality of the flat surface. Clarity and realism are thus sacrificed which can be seen by the predominance of simple frontal or profile views. The relation between drawing and sculpture is obvious for although both express the same understanding of representation, the drawings are works in their own right while at the same time they remain dependent on the sculptures. They are not based on the same formal concept but share the same spiritual foundation.

The two opposite poles of Funakoshi's art are on the one hand the inaccessibility of psychological expression and on the other hand the directness of the material presence. The occasional use of colour in the portrait drawings adds a further alienating effect which is similar to the more recent use of the addition of metal elements to his sculptures. These are the formal but also spiritual measures which lead away from a superficial realism.

The significance of Funakoshi's work at the end of this century lies in its ability to mediate, under the guise of realism, between presence and transcendence, between reality and artifice and so protect the one from the other. Despite being made of a natural material, Funakoshi's art turns against nature. It is not his aim to demonstrate the forces of nature by, for instance, emphasising the grain of the wood.

The beauty of Funakoshi's works is a created, formal and artificial beauty which despite being external reveals an inner beauty. The grace and dignity of Funakoshi's figures are more than mere reflections of the sensory world. Funakoshi achieves something remarkable that had seemed to be lost at the end of the Romantic period and only returned with the American abstract art of the 20th century: without any false pathos his figurative sculptures genuinely evoke the sublime. It is the ambivalence between time and its transcendence, or between presence and eternity and between individuality and universality which sets this reality, or one might even say truth, in motion.

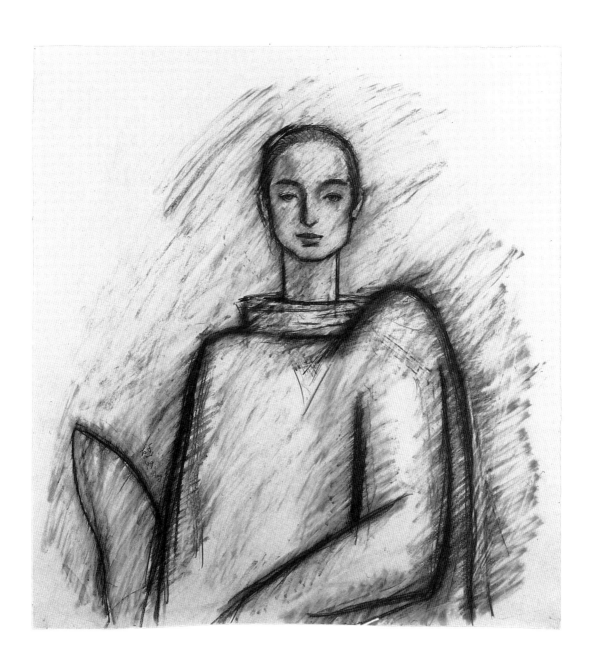

Drawing 9924, 1999

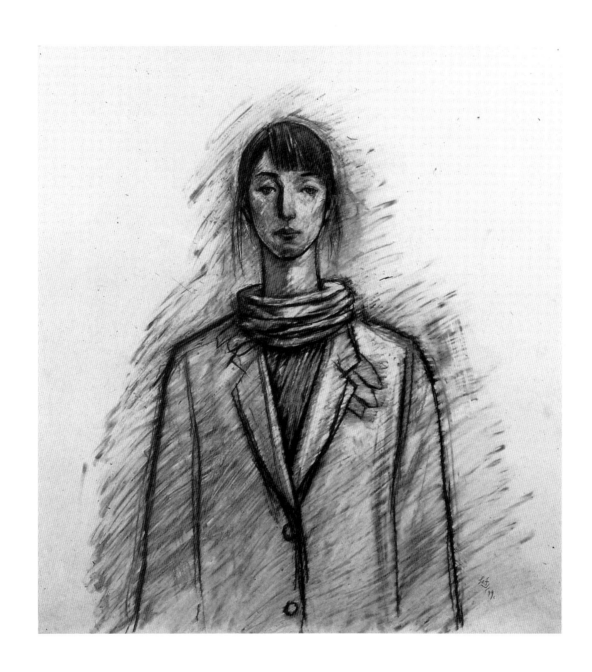

Drawing 9915, 1999

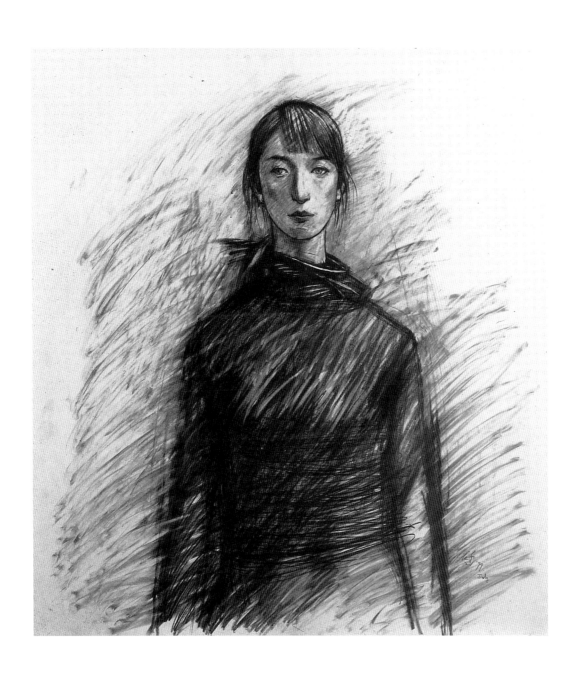

Drawing 9916, 1999

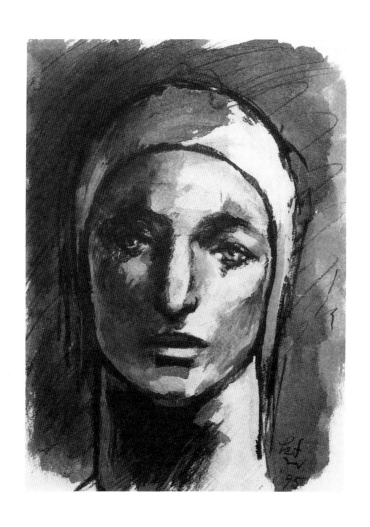

Drawing 9532, 1995

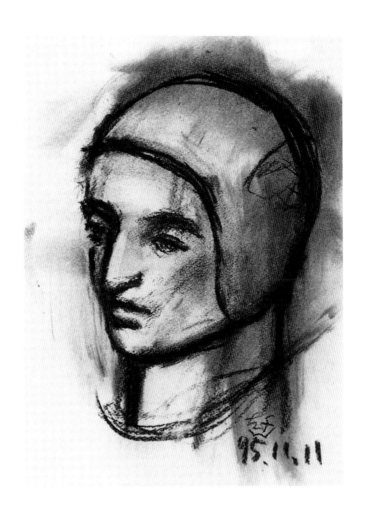

Drawing 9537, 1995

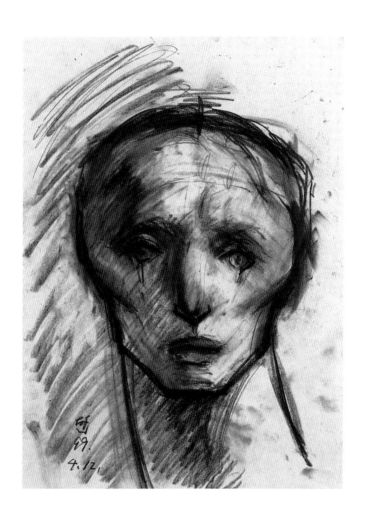

Drawing 9930, 1999

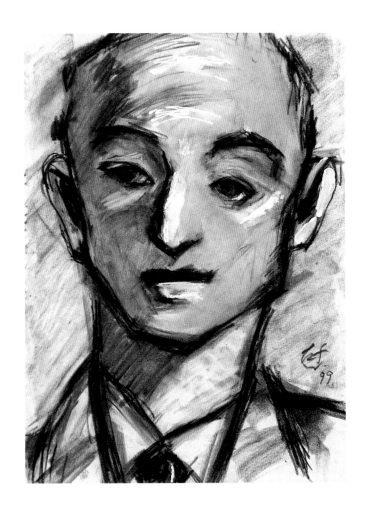

Drawing 9931, 1999

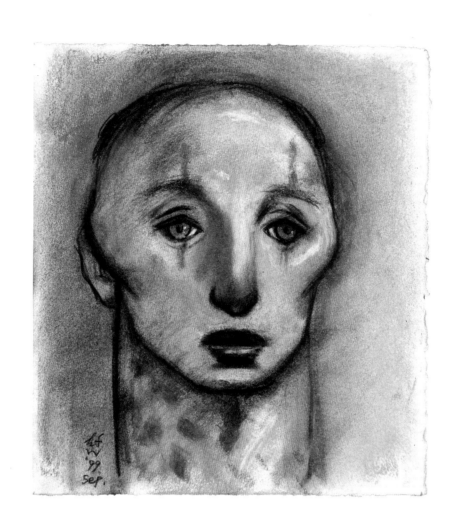

Drawing 9926, 1999

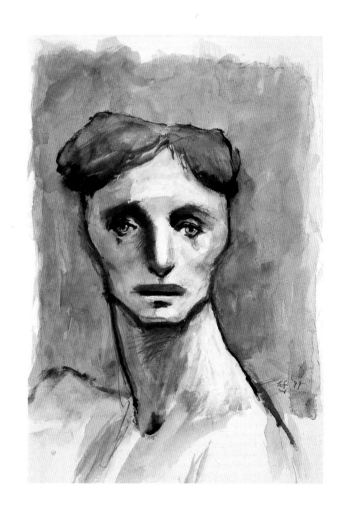

Drawing 9913, 1999

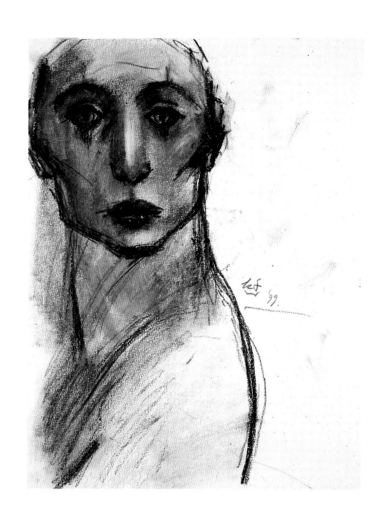

Drawing 9921, 1999

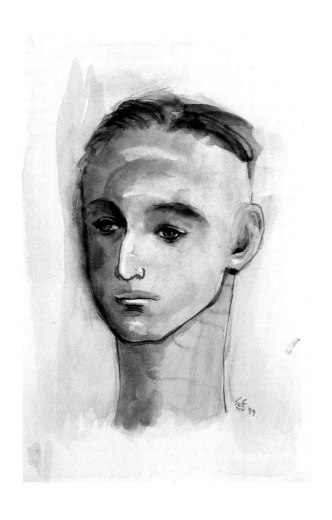

Drawing 9918, 1999

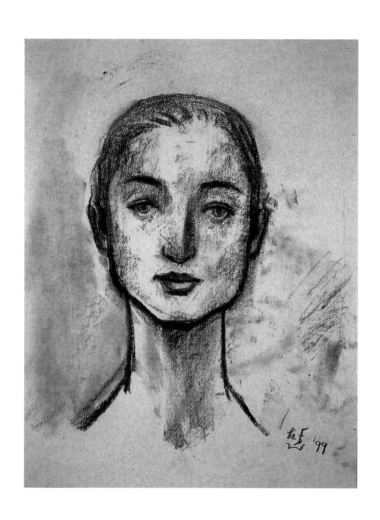

Drawing 9922, 1999

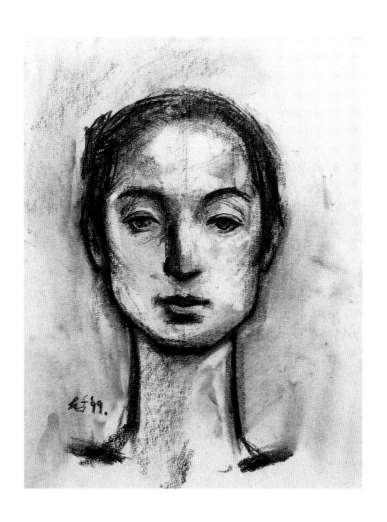

Drawing 9927, 1999

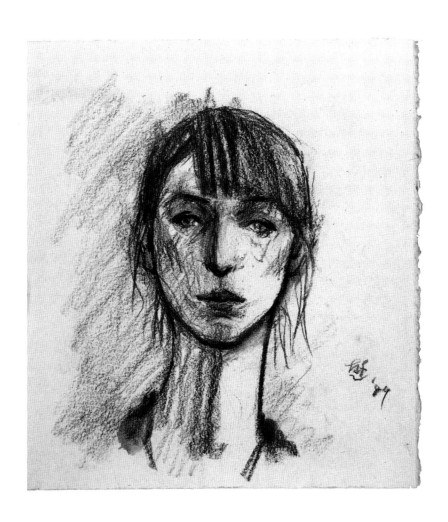

Drawing 9928, 1999

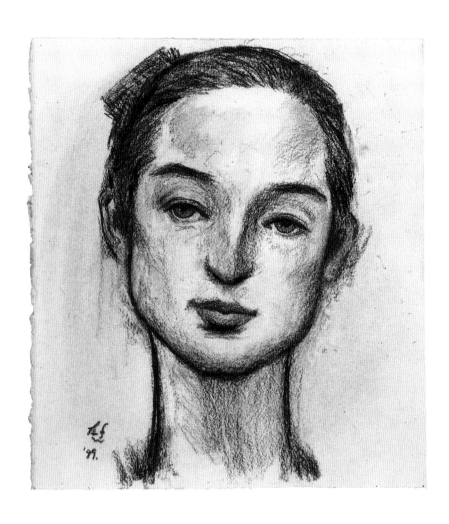

Drawing 9929, 1999

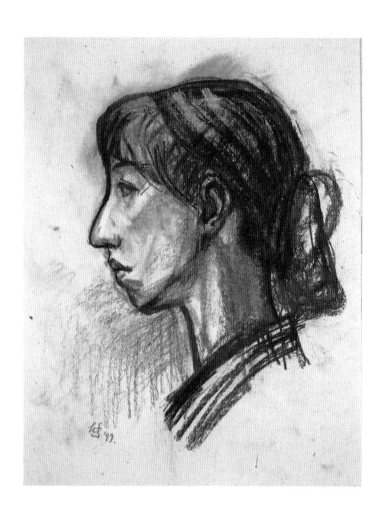

Drawing 9920, 1999

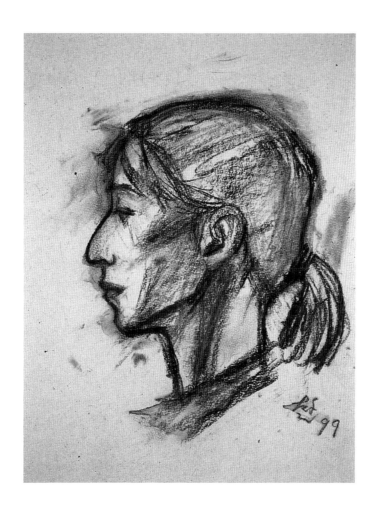

Drawing 9919, 1999

Biographie
Biography

Einzelausstellungen
One-Man Exhibitions

KATSURA FUNAKOSHI

1951 Born in Morioka City, Iwate Prefecture, Japan

1971 – 75 Studied at Tokyo University of Art and Design, B. A.

1975 – 77 Postgraduate Course at Tokyo National University of Fine Arts and Music, M. A.

1984 Awarded Excellence Prize *Oyama-City with Sculpture*

1985 – 86 Taught sculpture course at Tokyo National University of Fine Arts and Music

1986 – 87 Lived in London, one year scholarship from the Bureau of Cultural Properties

1989 – Teaches sculpture course at Tokyo University of Art and Design

1990 – 91 Taught sculpture course at Tokyo National University of Fine Arts and Music

1991 Awarded Takashimaya Charitable Trust for Art and Culture Prize

1995 Awarded the 26th Nakahara Teijiro Prize for Excellence

1997 Awarded the 18th Hirakushi Denchu Prize

Lives and works in Tokyo

1982 Gallery Okabe, Tokyo

1985 Nishimura Gallery, Tokyo

1988 Nishimura Gallery, Tokyo

1989 Comme des Garçons, Tokyo
 Arnold Herstand & Company, New York

1990 Nishimura Gallery, Tokyo (Drawings)

1991 Nishimura Gallery, Tokyo (Etchings)
 Annely Juda Fine Art, London

1993 Nishimura Gallery, Tokyo
 Museum of Modern Art, Kamakura

1994 Stephen Wirtz Gallery, San Francisco
 André Emmerich Gallery, New York

1995 Nishimura Gallery, Tokyo (Drawings)

1996 Annely Juda Fine Art, London
 Nishimura Gallery, Tokyo

1997 Ibara Municipal Denchu Art Museum, Okayama

1998 Bunkamura Gallery, Tokyo (Prints)

1999 Annely Juda Fine Art, London

2000 Kunsthalle Recklinghausen
 Städtische Museen Heilbronn

Ausgewählte Gruppenausstellungen
Selected Group Exhibitions

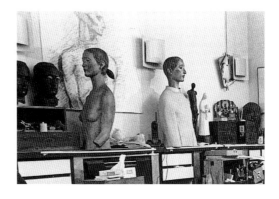

1976 – 84
Exhibition of New Figurative Sculpture, Tokyo
 Metropolitan Art Museum

1984
*10th Anniversary Exhibition of Sculpture of Ayumi
 Kai,* Chiba Prefectural Art Museum
Evolution of Sculpture 1930 – 1980, Gallery Seiho,
 Tokyo
Oyama-City with Sculpture, Oyama, Tochigi

1985
Black by 4 Artists, Morioka Daiichi Gallery, Iwate
Tama Vivant '85, Tama University of Fine Arts,
 Gallery SPACE 21, Tokyo
Nichido Sculpture, Gallerie Nichido, Tokyo

1986
Art in Tokyo '86 IMA, Factory, Tokyo
Three Artists, Nishimura Gallery, Tokyo
*New Trends in Contemporary Sculpture: 10 New
 Outstanding Sculptors of America and Japan,* Con-
 temporary Sculpture Centre, Tokyo and Osaka;
 Sapporo Art Park, Hokkaido; Salvatore Ala, New
 York

1987
*New Trends in Contemporary Sculpture: 5 Japanese
 Artists,* Salvatore Ala, New York
Shiga Annual '87: Expressions of Human Figures,
 The Museum of Modern Art, Shiga

1988
Contemporary Japanese Sculpture and Prints, The
 Rotunda, Exchange Square, Hong Kong
The XXXXIII Venice Biennale, Venice
Seven Sculptors, Nishimura Gallery, Tokyo

1989
Setagaya Art '88, Setagaya Art Museum, Tokyo
Sculpture Now, Gallery of Tokyu Department Store,
 Nihonbashi, Tokyo
Art Exciting '89, The Museum of Modern Art, Sait-
 ama
*Japanese Ways, Western Means – Art of the 1980s in
 Japan,* Queensland Art Gallery, South Brisbane
Sculpturesque Image, Gallery Haku, Osaka
Against Nature: Japanese Art in the Eighties, San
 Francisco Museum of Modern Art; Akron Art
 Museum; List Visual Art Center at MIT, Cam-
 bridge; Bank of Boston Art Gallery; Seattle Art
 Museum; The Contemporary Arts Center, Cin-
 cinnatti; Grey Art Gallery, New York University;
 Contemporary Arts Museum, Houston
XX Biennal de São Paulo 1989 Japão, São Paulo

1990
Transformation of Material and Space, Kanagawa
 Prefectural Hall Gallery, Yokohama
Inside Eye: The 1st – 1990, Tokyo Ginza Art Cen-
 tre; Kyoto Art Centre
Toyama Now '90, The Museum of Modern Art,
 Toyama
New Wave of Wood Sculptures, Hokkaido Asahi-
 kawa Museum of Art
Japanische Kunst der 80er Jahre, Frankfurter Kunst-
 verein and tour

1991
Setagaya Art '91, Setagaya Art Museum, Tokyo
Against Nature: Homecoming Exhibition, ICA
 Nagoya
A Current of Contemporary Art in Japan: Sculpture,
 The Museum of Modern Art, Toyama

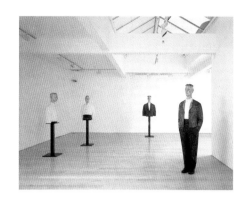

1992
Prediction, Nishimura Gallery, Tokyo
*Japanese Modern and Contemporary Wood Sculpt-
ures,* The Okayama Prefectural Museum of Art
Documenta IX, Kassel
9th Biennale of Sydney

1993
Tsubaki-kai Exhibtion '93, Shiseido Gallery, Tokyo
Karuizawa Drawing Biennale 1993, Wakita Museum
of Art, Karuizawa-machi, Nagano and Maru-
game Genichiro Inokuma Museum of Contemp-
orary Art, Marugame City, Kagawa

1994
Setagaya Art '94, Setagaya Art Museum, Tokyo
Contemporary Human Figure, Hokkaido Museum
of Modern Art, Sapporo
New Works at New Gallery, Nishimura Gallery,
Tokyo
A Sculpture Show, Nishimura Gallery, Tokyo

1995
Art in Japan Today 1985 – 1995, Inaugural Exhibi-
tion, Museum of Contemporary Art, Tokyo
Tsubaki-kai '95, Shiseido Gallery, Tokyo
*Japanese Culture: The Fifty Postwar Years
1945 – 1995,* Meguro Art Museum; Hyogo Pref-
ectural Museum of Modern Art, Kobe; Hiroshima
City Museum of Contemporary Art; Fukuoka
Prefectural Museum of Art

1996
Kunst des 20. Jahrhunderts, Museum Ludwig, Köln
Narcissism: Artists Reflect Themselves, California
Center for the Arts Museum, Escondido
Enjoy Art Part II, ISETAN Museum, Tokyo

Masterpiece of Corporation Collection, Hotel Okura,
Tokyo
*The 45th Anniversary, Part 1 – A Dialogue between
Tools and Arts,* The Museum of Modern Art,
Kamakura
*Images of Women in Japanese Contemporary Art
1930s – 90s,* The Shoto Museum of Art, Tokyo

1997
5th NICAF Tokyo '97, International Contemporary
Art Festival, Tokyo International Exhibition Center
Collection I – Sculpture, Nishimura Gallery, Tokyo
On Paper '97, Nishimura Gallery, Tokyo

1998
Setagaya Art '98, Setagaya Art Museum, Tokyo
ART – Selected Works from the Collection, Aichi
Prefectural Museum of Art, Nagoya
Human Figure, Asahikawa Sculpture Museum
Art 1998 Chicago, Festival Hall, Navy Pier, Chicago
Summer Show 1998, Nishimura Gallery, Tokyo
ACAF 6, Royal Exhibition Building, Melbourne

1999
Setagaya Art '99, Setagaya Art Museum, Tokyo
Image of Sculpture, Asahikawa Sculpture Museum
France – Japon – L'Art Sans Frontière, Bunkamura
Gallery, Tokyo
*Noontime Meditation – Contemporary Japanese Art
Having Inner Sight,* Tochigi Prefectural Museum
of Fine Arts, Utsunomiya
Summer Show 1999, Nishimura Gallery, Tokyo
NICAF Tokyo '99, International Contemporary Art
Festival, Exhibition Hall, Tokyo International
Forum
Selected Works from the Permanent Collection,
Tokyo Opera City Art Gallery

Öffentliche Sammlungen
Public Collections

Bibliographie
Bibliography

Aichi Prefectural Museum of Art, Nagoya
Asahikawa Sculpture Museum
Gotoh Museum of Art, Tokyo
Hiroshima City Museum of Contemporary Art
Hokkaido Asahikawa Museum of Art
Ishinomaki City Cultural Centre, Miyagi Prefecture
Iwaki City Art Museum
Iwate Prefecture
Kurume City, Fukuoka
McMaster Museum of Art, Hamilton, Canada
Museum Ludwig, Köln
Museum of Contemporary Art, Tokyo
Museum of Contemporary Sculpture Affiliated
 Chosen-in Temple, Tokyo
Nagoya City Art Museum
Nogi-machi, Tochigi Prefecture
Our Lady of the Light House Trappist Monastery,
 Hakodate
Setagaya Art Museum, Tokyo
Shiseido Art House, Kakegawa
Sumida Triphony Hall, Tokyo
St Andrew's Church, Tokyo
Takamatsu City Museum of Art
The Metropolitan Museum of Art, New York
The Museum of Art, Kochi
The Museum of Modern Art, Kamakura
The Museum of Modern Art, Toyama
Tochigi Prefectural Museum of Fine Arts, Utsunomiya
Tokushima Prefectural Museum of Modern Art
Zushi Catholic Church, Kanagawa

Bücher • Books

1991
Sculpture as Image, (chapter 7) in Janet Koplos,
 Contemporary Japanese Sculpture, Abbeville Press,
 New York

1992
The Day I Go To The Forest – Katsura Funakoshi,
 Kyuryudo, Tokyo; contains *The Sculpture of
 Katsura Funakoshi: Echoes of Life* by Akira Ooka
 and *To Look at Distant People – Katsura Funa-
 koshi* by Tadayasu Sakai
*Contemporary Artists in Japan, Sculptors and Instal-
 lation Artists 133,* Nihon Enshutsu

1995
Water – Its Transformation: Katsura Funakoshi
 Kyoto-shoin, Kyoto, contains foreword by the
 artist, *Silent Space: Works of Katsura Funakoshi,*
 by Atsuko Suga and *The Transparent Enclosure of
 Air: Katsura Funakoshi's Sculptures* by Tsutomu
 Mizusawa

1996
Tone O. Nielsen, *Et Andet Japan,* Tiderne Skifter,
 Copenhagen

1997
Excuse of Making Toys, Suemori Books, Tokyo

1998
Words Falling On Wood, Kadakawa Publishing,
 Tokyo

Ausstellungskataloge • Exhibition catalogues

1985
Katsura Funakoshi – Sculptures, Nishimura Gallery,
Tokyo, text by Seiji Oshima

1986
*New Trends in Contemporary Sculpture: 10 New
Outstanding Sculptors of America and Japan,* Con-
temporary Sculpture Center, Tokyo and Osaka,
contains essays by Tadayasu Sakai and the artist
Art in Tokyo '86 IMA Vol. 1, Factory, Tokyo, con-
tains *Katsura Funakoshi, Takashi Fukai – Two
Time Space Trippers* by Hiroshi Aoki
Funakoshi, Kondo, Senzaki, Nishimura Gallery,
Tokyo, contains *Sculpture by Katsura Funakoshi*
by Takahiko Okada

1987
Shiga Annual '87 – Expressions of Human Figures,
The Museum of Modern Art, Shiga
*New Trends in Contemporary Sculpture: 5 Japanese
Artists,* Salvatore Ala, New York contains *Katsura
Funakoshi – Someone Like You* by Tadayasu Sakai
and *My aim is to create sculpture which evokes a
sense of someone being here, standing by one's
side ...* by the artist

1988
Setagaya Art '88, Setagaya Art Museum, Tokyo
Contemporary Japanese Sculpture and Prints, The
Rotund Exchange Square, Hong Kong, contains
*The Quiet Persuasion of Contemporary Japanese
Sculpture* by Tadayasu Sakai
Giaponne, La Biennale di Venezia, The Japan Foun-
dation, contains *Con Enkú si apre (It starts with
Enku)* and *L'uomo d'incontro* by Tadayasu Sakai,

and *Il legno ed io* by the artist
Katsura Funakoshi, Nishimura Gallery, Tokyo, con-
tains *The Hand of Imagination* by Tadayasu Sakai
and *I encountered a plank in Venice ...* by the artist

1989
Art Exciting '89, The Museum of Modern Art, Saitama
*Japanese Ways, Western Means – Art of the 1980s in
Japan,* The Queensland Art Gallery, Brisbane,
contains *Switching Channels* by Masayoshi
Homma, *Japanese Ways, Western Means* by
Michel Sourgnes, and *If art is lined up to resemble
steeping stones in the garden ...* by the artist
Against Nature: Japanese Art in the Eighties, San
Francisco Museum of Modern Art; Akron Art
Museum; List Visual Art Center at MIT, Cam-
bridge; Bank of Boston Art Gallery; Seattle Art
Museum; The Contemporary Arts Center, Cin-
cinnati; Grey Art Gallery, New York University;
The Contemporary Arts Museum, Houston; The
Japan Foundation, contains *Profile, Katsura Funa-
koshi* by Katy Halbreich and Thomas Sokolowski
XX Biennal de São Paulo 1989 Japão, The Japan
Foundation, contains *O Homem de Caixa (The
Box Man)* by Tadayasu Sakai and *Encontro com
uma poessoa de vosã o futuristica (Meet a far-sigh-
ted person)* by the artist

1990
Transformation of Material and Space, Kanagawa
Prefectural Hall Gallery, Yokohama
Inside Eye The 1st – 1990, Tokyo Ginza Art Center;
Kyoto Art Center
Gotoh Collection I, Gotoh Museum of Art, Tokyo
*Toyama Now '90 – The 4th International Contemp-
orary Art Exhibition,* The Museum of Modern Art,
Toyama, contains *In Japan and in the World* by

Kenji Otsubo and *Perhaps it may be that I have no clear idea ...* by the artist
Japanische Kunst der 80er Jahre (Frankfurter Kunst-verein / The Japan Foundation), contains fore-word by Peter Weiermair, *Die Japanische Identität* (The Japanese Identity) by Fumio Nanjo, *Versuch einer Betrachtung des geistigen Hintergrunds der zeitgenössischen japanischen Kunst der achtziger Jahre* (Attempt at a reflection on the spiritual background of contemporary Japanese art of the Eighties) by Yukio Kondo and *Katsura Funa-koshi* by Makoto Murata
New Wave of Wood Sculptures, Hokkaido Asahi-kawa Museum of Art

1991
Setagaya Art '91, Setagaya Art Museum, Tokyo
Katsura Funakoshi – Sculpture, Annely Juda Fine Art, contains *Number of Words Arrived* by Marina Vaizey
A Current of Contemporary Art in Japan – Sculpture, The Museum of Modern Art, Toyama

1992
Japanese Modern and Contemporary Wood Sculp-tures, The Okayama Prefectural Museum of Art
Documenta IX, Kassel
The Boundary Rider, 9th Biennale of Sydney, The Biennale of Sydney, contains *Katsura Funakoshi* by Anthony Bond

1993
Katsura Funakoshi, Nishimura Gallery, Tokyo
Tsubaki-kai '93, Shiseido Gallery, Tokyo, contains *I have kept my father waiting for more than thirty years ...* by the artist
Today's Artists V '93, The Museum of Modern Art, Kamakura, contains *Light Up A Room* by the artist,

Decline of the Horizon by Tsutomu Mizusawa and interview with the artist by Tsutomu Mizusawa
Karuizawa Drawing Biennale 1993, Wakita Museum of Art, Karuizawa-machi, Nagano and Maruga-me Genichiro Inokuma Museum of Contempor-ary Art, Marugame City, Kagawa, contains *The Life of a Drawing* by Kijima Shunsuke

1994
Setagaya Art '94, Setagaya Art Museum, Tokyo
Katsura Funakoshi, Stephen Wirtz Gallery, San Francisco, contains *Katsura Funakoshi: Gazing into the Middle Distance* by Maria Porges
Contemporary Human Figure, Hokkaido Museum of Modern Art, Sapporo
New Works at New Gallery, Nishimura Gallery, Tokyo

1995
Art in Japan Today 1985 – 1995, Museum of Con-temporary Art, Tokyo
Japanese Culture: The Fifty Postwar Years 1945 – 1995, Meguro Art Museum; Hyogo Prefectural Museum of Modern Art, Kobe; Hiroshima City Museum of Contemporary Art; Fukuoka Prefectural Museum of Art
Tsubaki-kai '95, Shiseido Gallery, Tokyo, contains *About Mr Funakoshi* by Kenji Nishimura

1996
Katsura Funakoshi – Recent Sculpture and Drawings, Annely Juda Fine Art, London
Funakoshi Katsura 1995 – 1996, Nishimura Gallery Tokyo, contains *Distant Memories: Three Chapters on Katsura Funakoshi* by Kunio Yaguchi
Kunst des 20. Jahrhunderts, Museum Ludwig, Köln

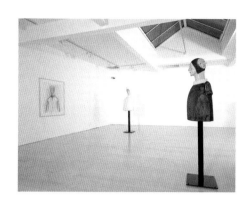

Narcissism: Artists Reflect Themselves, California
 Center for the Arts Museum, Escondido, cont-
 ains *Peeping over the Wall* by John Welchman
Enjoy Art Part II, ISETAN Museum, Tokyo
Masterpiece of Corporation Collection, Hotel Okura,
 Tokyo
*The 45th Anniversary, Part 1 – A Dialogue between
 Tools and Arts,* The Museum of Modern Art,
 Kamakura
*Images of Women in Japanese Contemporary Art
 1930s – 90s,* The Shoto Museum of Art, Tokyo

1997
5th NICAF Tokyo '97, International Contemporary
 Art Festival, Tokyo International Exhibition Center
On Paper '97, Nishimura Gallery, Tokyo
Katsura Funakoshi, Ibara Municipal Denchu Art
 Museum, Okayama

1998
Setagaya Art '98, Setagaya Art Museum, Tokyo
Art 1998 Chicago, Festival Hall, Navy Pier, Chicago
Summer Show 1998, Nishimura Gallery, Tokyo
ACAF 6, Royal Exhibition Building, Melbourne

1999
Setagaya Art '99, Setagaya Art Museum, Tokyo
*Noontime Meditation – Contemporary Japanese Art
 Having Inner Sight,* Tochigi Prefectural Museum
 of Fine Arts, contains *Meditation Art – Can the
 Meaning of Art Be Recovered* by Reiko Kokatsu
Selected Works from the Permanent Collection, Tokyo
 Opera City Art Gallery
*Katsura Funakoshi – Skulpturen und Zeichnungen,
 Sculptures and Drawings;* Annely Juda Fine Art,
 London; Kunsthalle Recklinghausen; Städtische
 Museen Heilbronn; contains *Katsura Funakoshi,*

*Skulptur zwischen zwei Kulturen • Sculpture between
two Cultures – Katsura Funakoshi* by Anna Bechi-
nie, *„... nicht zur hart und nicht zu weich" Kampfer-
holz – das Material der Skulpturen Funakoshis* • '...
*not too hard and not too soft' Camphor Wood – The
Material of Funakoshi's Sculptures* by Dieter Brun-
ner, *Wirklichkeit und Wirksamkeit im Werk von
Katsura Funakoshi* • *Reality and its Effect – The
Work of Katsura Funakoshi* by Ferdinand Ullrich

Kritiken und Essays • Reviews and Essays

1983
Essay by the Artist, Atelier, May

1984
Hisao Matsumura, Sankei Shimbun, 15 June

1985
Shin Bijutsu Shimbun, 21 March
Kohjin Tanaka, Mainichi Shimbun, 29 March
Mamoru Yonekura, Asahi Shimbun, 30 March
Ikuro Takano, Interview, Variety, April
Hisao Matsumura, Sankei Shimbun, 5 April
Geijutsu Shincho, May
Kunihiko Takei, Review, Sansai, May
Katsura Funakoshi, Interview, Bijutsu Techo, June
Junichi Shioda, Art 85, August

1986
Interview, Acrylart, 30 August
Peter Mollenkof, *Works of 3 Young Artists,* The
 Japan Times, 28 September
Janet Koplos, *In Nothing Something,* Asahi Evening
 News, 3 October
Nigel Cameron, *Sculpture with Enigma,* Hong Kong
 Standard, 9 November

1987
Salvatore Ala, *New Trends in Contemporary Sculpture,*
 Art News, November
Katsura Funakoshi, *Artist's Studio with Sounds,* Gei-
 jutsu Shincho, December

1988
Janet Koplos, *Sculpture: The Premier Contemporary
 Art,* Winds, March
Edward M. Gomez, *Making Way for Japan,* The
 Japan Times, 21 March
Roberto Tassi, *Bocche, tronchi rami e seppie,* La
 Repubblica sabato, 25 June
Marina Vaizey, *Nations Talking in Too Many
 Tongues,* The Sunday Times, 26 June
William Packer, *Hard sell of Jasper Johns: Venice
 Biennale,* Financial Times, 30 June
John Russell Taylor, *Smaller is Beautiful,* The
 Times, 1 July
Giles Auty, *Have Linen Jacket Will Travel,* The Spec-
 tator, 2 July
William Feaver, *Venice is sinking ...,* The Observer,
 3 July
Jürgen Hohmeyer, *Schatten im Bild,* Der Spiegel,
 4 July
Vittorio Fagone, *New Art in the New Japan,* Cont-
 emporanea, 8 July
Edward M. Gomez, *Asian Artists Seize the Moment,*
 RICE, August
Janet Koplos, *Enku's Heirs,* Asahi Evening News,
 19 August
Yasushi Kurahashi, Bijutsu Techo, September
Venice Biennale Report Vol. 1, Atelier, October
Seiichi Hoshino, *New Age of Contemporary Sculpt-
 ure Vol. 1,* Art Magazine, October
Toti Carpentieri, *Il Trionfo della Scultura,* Arte, October
Shin Bijutsu Shimbun, 21 November

Haruo Sanda, Mainichi Shimbun, 25 November
Yomiuri Shimbun, 26 November
Chikon Terada, Tokyo Shimbun, 30 November
Sankei Shimbun, 1 December
Report by Makoto Murata, Shin Bijutsu Shimbun,
 1 December
Janet Koplos, *Careful Balances,* Asahi Evening
 News, 2 December
Taiji Yamaguchi, Akahata, 6 December
Mamoru Yonekura, Asahi Shimbun, 7 December
Mamoru Yonekura, Asahi Shimbun Marion,
 15 December

1989
Face '89, Sankei Shimbun, 1 January
Round Table Talk Part 1 & Part 2, Gallery,
 February/March
Kiyoshi Matsui, Yomiuri Shimbun, 22 March
Janet Koplos, *Through the Looking Glass – A Guide
 to Japan's Contemporary Art World,* Art in Amer-
 ica, July
Makoto Murata, *Katsura Funakoshi,* Artcount, Vol. 1
Hito Plus 1, Asahi Shimbun, 29 July
Katsura Funakoshi, Nishimura Gallery, Tokyo,
 review by Janet Koplos in Sculpture, July/August
Christine Tanblyn, *Against Nature – Japanese Art in
 the Eighties,* Art News, September
Japoneses tranzem a "arte do hoje" para a Biennal,
 Journal Paulista, 13 October
Yasuyoshi Saito, *4 Days Gallery,* The Tokyo Times,
 23 – 26 October

1990
Artists Talk, Gallery, January
Michael Brenson, *Review/Art Katsura Funakoshi,*
 The New York Times, 5 January
Jason Edward Kaufman, *Three Young Artists, Solo*

Shows, New York City Tribune, 18 January

Drawing '90, Yomiuri Shimbun, 17 February

Janet Koplos, *West Meets East ...,* Reflex, March/April

Eleanor Heartney, *Katsura Funakoshi at Herstand,* Art in America, April

Eleanor Heartney, *Mixed Messages,* Art in America, April

Hiromichi Abukawa, Asahi Shimbun, 13 June

Chikon Terada, Tokyo Shimbun, 15 June

Sankei Shimbun, 21 June

Joel Perron, *Austere beauty resonates from sculptor's wooden figures,* The Japan Times, 24 June

Norio Sugarawa, Yomiuri Shimbun, 25 June

Kenji Ishikawa, Mainichi Shimbun, 20 July

Constance Lewallen, *Interview with Katsura Funakoshi, August 1990,* View, Vol. VII, No. 3, Fall

Dessin, Sankei Shimbun, 29 November

Report *New Wave of Wood Sculptures,* Hyo-ka (Hokkaido Asahikawa Museum of Art), 28 December

World of Katsura Funakoshi, Ginka, Winter

1991

Julia Fendrick, *Contemporary Japanese Sculpture: Artifice vs. Nature,* Sculpture, January/February

Distant eyes of the Holy Mother: Katsura Funakoshi Interview, NEURON 32, On the Line, February

Friedrich Geyrhofer, *Im Reich der Sony – Japanische Kunst der achtziger Jahre in Wien,* Wiener, February

Sculptor, Katsura Funakoshi, Katei Gaho, March

Katsura Funakoshi, *Catalogue Raisonné of Etchings;* Sumio Kuwabara, *The Form of Present; My Etching Diary* by Katsura Funakoshi and interview by Constance Lewallen, 21st Century Prints, April

Nagoya – Against Nature, Mainichi Daily News, 11 April

The Clarified Distance: Katsura Funakoshi, Doom (Museum of Modern Art, Toyama), 20 April

Hiromichi Abukawa, Asahi Shimbun, 28 June

Leza Lowitz, *Perfect Balance of Impulses,* Asahi Evening News, 29 June

Brutus, Art Infopack, July

Yoshikazu Tomita, *Artist's Breaktime,* Shim Bijutsu Shimbun, 1 July

Hisao Matsumura, Sankei Shimbun, 1 July

Tsuyuhiko Hinatsu, *Dignity of Existence,* Asahi Evening News, 21 July

William Packer, *Where to go, what to see – Japan Festival,* Financial Times, 15 September

John Russell Taylor, *Rising sons, new horizons,* The Times, 20 September

William Feaver, *Godzilla meets the God of Fire,* The Observer, 22 September

William Packer, *Sublime to the ridiculous,* Financial Times, 24 September

Mary Rose Beaumont, *London Reviews: Katsura Funakoshi,* Arts Review, 4 October

Geraldine Norman, *Contemporary Art Market,* The Independent, 7 October

Sue Hubbard, *Katsura Funakoshi, Annely Juda Fine Art,* Time Out, 9 – 16 October

John McEwen, *Critics' Choice,* Sunday Telegraph, 10 October

Spiral Paper, No. 34, November/December

1992

Thomas Wagner, *Die Kunst schlägt Purzelbaum,* Frankfurter Allgemeine Zeitung, 17 June

1993

Roland Hagenberg, *Japanische Kunst, Verbrennen, Verkleiden, Verfilmen,* Vogue (German edition), January

Geraldine Norman, *Japanese artists discover wave of enthusiasm in the West,* The Independent, 27 December

1994

Thomas Gladyaz, *San Francisco Scene,* Art-Talk
Newspaper

David Bonetti, *Filling the Space between East and
West,* San Francisco Examiner, 21 January

Kenneth Baker, *The Mythic Appeal of Movements,*
The San Francisco Chronicle, 23 January

*Sculptor Katsura Funakoshi Explores a New Print
Series,* The Wise Collection, February

Roland Hagenburg, *Yen and the Art of Collecting,*
Japan International Journal, April

Kay Itoi, *Hot Young Japanese Sculptor,* Art News
Letter, 19 April

Righa Royal News, May

Katja Blomberg, *Im Feld der toten Dinge – Drei japa-
nische Bildhauer,* Frankfurter Allgemeine Zeitung,
30 July

Preview Funakoshi at André Emmerich, ART NOW
Gallery Guide, November

1995

Janet Koplos, *Katsura Funakoshi,* Sculpture,
March/April

Masaaki Iseki, *Between Human Beings and Trees,*
Journal of Japanese Trade & Industry, June/July

Eduard Beaucamp, *Die Kunst sucht ihre Zeit,* Frank-
furter Allgemeine Zeitung, Feuilleton, 22 July

1996

John Russell Taylor, *... and, also in London, the
mysterious wood sculptures of Katsura Funakoshi
go on display,* The Times, 23 January

Sarah Kent, *Katsura Funakoshi,* Time Out,
24 – 31 January

William Packer, *Renaissance from the East,* The
Financial Times, 27 January

James Hall, The Guardian, 30 January

Heidi Bürklin, *Menschenbilder zum Meditieren,* Die
Welt, March

Blicke in die Unendlichkeit der Seele, Art, March

Tsubuyaki Gallery, Optim, Vol. 1, November

Arturo Silva, *Metamorphoses of a Craft – Sculptures
in Wood, Marble and Print,* The Japan Times,
24 November

1997

Nikkei Art, January/February

Asahi Shimbun, 1 March

Yomiuri Shimbun, 1 March

Shin Bijutsu Shimbun, 21 April

Essay by the artist, Shin Bijutsu Shimbun, 1 June

Suisho Moriguchi, Asahigraph, 1 August

1998

Georgiana Adam, *Katsura Funakoshi,* Asian Art,
February

Art Now Gallery Guide, International Edition, May

Art 1998 Chicago, Where Chicago, May

Haruo Sanda, *Contemporary Artists Line Up,*
AMUSE, 27 May

Tadayasu Sakai, *Sculptor's inner voice,* Ho no Tabib-
ito, December

1999

Feature Katsura Funakoshi, *Catalogue Raisonné of
Prints 1987 – 98* and interview, Hanga Geijutsu
No. 104

Book Review, Sogetsu No. 242, February

Book Review, Mainichi Shimbun, 28 February

Haruo Sanda, Mainichi Shimbun, 15 July

Abgebildete Werke
Reproduced Works

Inhalt · Contents